As featured in the

PERIDOT PICTURES
PBS special:

"JENNY"

In the footsteps of giants . . .

*I could hardly wait to read [this book, and] I was certainly
not disappointed. It's an excellent combination of high quality
photography (considering the era) and first-person narrative of the
experience of learning to fly in the Curtiss Jenny. I found the book
engrossing. I could hardly put it down. Although I'm an avid aircraft
history book reader I've not encountered anything like it before. I
highly recommend it. Thank you Bill for a job very well done.*

Lamar Bevil
Moderator
WOODEN PROPELLER.com

VINTAGE PHOTO ALBUM SERIES™

1919

Learning to Fly in a "Jenny"
Just Like Charles Lindbergh and Amelia Earhart

WILLIAM BOLLMAN

FOREWORD BY CHUCK YEAGER

ISBN: 978-1-4669-8107-2 (sc)
ISBN: 978-1-4669-8171-3 (e)

Library of Congress Control Number: 2013903105

Trafford rev. 02/15/2013

 www.trafford.com

North America & international
toll-free: 1 888 232 4444 (USA & Canada)
phone: 250 383 6864 ♦ fax: 812 355 4082

CONTENTS

To my kids:

Abigail Bollman,
Ally Bollman,
&
John Bollman.

FOREWORD

Although I did not learn to fly in a JN-4 Jenny, I did get to fly the Jenny in later years. It was quite an experience. I was military trained in PT-21, BT-13 and T-6 aircraft during 1942. During the late 50's, while flying the X-1 for the movie "Jet Pilot", I became good friends with Paul Mantz, who was filming the movie. He told me Frank Tallman and he had quite a few old airplanes that were in flying condition and that I could fly all of them as much as I pleased. The list included the JN-4 Jenny, the Spirit of St. Louis, the P-12, the P-26 and others.

While flying the collection of old airplanes I was surprised to find how unstable the old airplanes were. The Jenny was the worst. One could yaw the Jenny 10 or 15 degrees, then take one's feet off the rudder, and the Jenny would keep flying in a yaw.

The pilots who flew the old airplanes had to be on the controls all the time. The P-12 & P-26 were a bit better and were a pleasure to fly. I have flown over 341 different military models and types in every country in the world at speeds above MACH 3 and above 100,000 feet.

Modern pilots who fly today have it easy compared to the early pilots, because of design improvements. I admire old guys and gals like Jimmy Doolittle and Jackie Cochran, who had it rough.

It is interesting to read William Bollman's book about how rough the early pilots had it before World War I. The schedule he lists then is not much different from ours in 1942.

I am very lucky to have flown the airplanes that I did over a 70 year period; fighting in 4 wars, and training and flying test airplanes on the cutting edge of technology.

I enjoyed every minute of it.

CHUCK YEAGER
B/Gen USAF (ret.)

PROLOGUE

The TRIP BACK IN TIME: Vintage Photo Album Series™ of books is quite unique. Most photo books about historical places provide photos taken over many years, some old, some more recent, and most photos having been published before. Each book in the TRIP BACK IN TIME: Vintage Photo Album Series™ instead explores an extraordinary amateur vintage photo album of photos generally from ONE year, of a given location, trip or subject, and always having never been published before. Every vintage photo album tells its own unique story; the older the photo album the more challenging it is to uncover the details of its story.

This entry in the TRIP BACK IN TIME: Vintage Photo Album Series™ focuses on Edward O. Southard's photo album from nearly 100 years ago documenting his experiences in learning to fly in a Curtiss JN-4 "Jenny" at March Field in Riverside, California. The year was 1919.

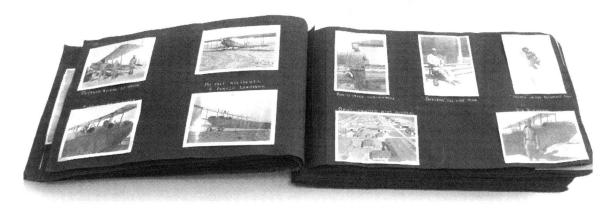

Edward used a Brownie No. 2 box camera from Kodak, which can be seen in the following photo from his album. (That's Edward on the right.)

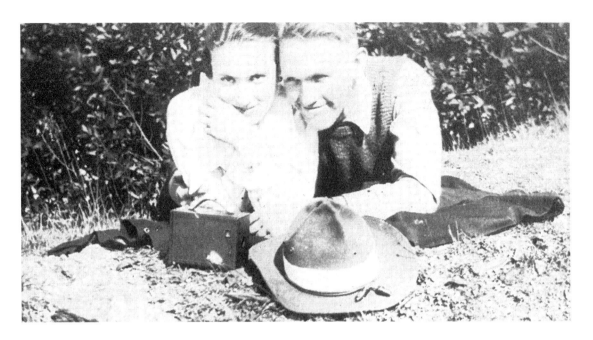

One can't imagine hanging outside an open-air 'Jenny' biplane that you're learning how to fly, taking photos with a Kodak Brownie No. 2 box camera, but at times, for our enjoyment nearly 100 years later, that is exactly what Edward did.

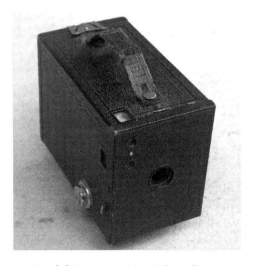

A Kodak Brownie No. 2 Box Camera

William Muir Russel

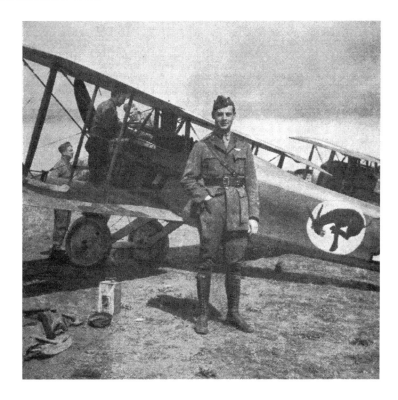

The story of Edward's photo album of an early flying school in 1919 is told using excerpts from letters written by another early pilot: American aviator William Muir Russel. William Russel's letters were published in 1919 in the book "A Happy Warrior: Letters of William Muir Russel," and tell in fantastic detail what it was like for him to learn to fly in a Jenny.

Edward Southard learned to fly in Jennys at March Field in California; William Russel at Ashburn Field and then Rantoul Aviation Field, both in Illinois, about 18 months earlier. But that's where the differences in their early flying school experiences end. They both learned to fly in the same plane, they both saw frequent crashes, they both mastered the same controls, take-offs and landings, and they both first flew solo in a Jenny. The result of introducing William Russel's literary talents (he was a journalism major at college) to Edward Southard's photographic abilities, envelopes the

reader in the same inspirational journey taken by some of our earliest pilots. We are honored to introduce William Russel and Edward Southard to one another, and have them together tell the story of what it was like to learn to fly in the same plane that Amelia Earhart first learned to fly in, and in the same plane that Charles Lindbergh first soloed in, in this entry in the TRIP BACK IN TIME: Vintage Photo Album Series™.

Curtiss JN-4 "Jenny" Bi-plane

1919 was very early in the history of fixed-wing powered flight. Most citizens had still never seen an airplane up close. While the Wright brothers had achieved the first fixed-wing powered flight in late 1903, they kept their secrets close to the vest as they applied for a patent on their "Flying machine." Their patent ultimately was awarded in 1906, as U.S. Patent Number 821393.

This was an important patent in the United States, to be sure, but the Wright brothers' efforts with the patent and deep involvement with the subsequent enforcement of it left them with less time to adequately develop their flying machine. As a result, the Wright brothers made no flights at all

in 1906 and 1907, and competitors started to fill the gap. In 1908 Glenn Curtiss and other early aviators attempted to work-around the patent in the US, while development of aeroplanes (as they were called back then) proceeded unencumbered in Europe. Ultimately the Wright brothers would prevail on their patent lawsuits, but while they were preoccupied with enforcement of their patent, Curtiss built a company to manufacture aircraft (and filed for his own patents.) Because of all this legal distraction, (not to mention that one of the brothers, Wilber Wright, would die of typhoid in 1912) there weren't many customers for aeroplanes for many years after the Wright brothers' first flight, nor were there many pilots. Even through 1916, Orville Wright and his Wright Company flying school had trained a total of only 115 pilots.

In 1917, civilian flights in the United States were banned for the duration of World War I, so the military was the only place to learn to fly. As the need for aeroplanes became driven by World War I, there was a call for pilots to fly them. And thus, the legend of the Curtiss JN-4 "Jenny" was born over the better part of the next decade with its near exclusive use in flying schools, and subsequent surplus sales for civilian use.

The point to be made is that 1919 was still a very early time for airplanes (or "aeroplanes"), and the Curtiss Jenny was our first widely available plane. This entry in the TRIP BACK IN TIME: Vintage Photo Album Series™ tells the story of what it was like to be among the very first to learn to flight-essentially at a time when very few had seen a plane up close, much less knew how to fly one.

The first Curtiss JN series bi-plane, nicknamed the "Jenny" from the designation "JN", was built in 1914, with a wheel to control the ailerons and a foot bar to control the rudder. After a few revisions, the JN-4D was introduced in 1917, which replaced the wheel with a control stick.

The Jenny had a wood frame with a fabric covering, and until you step into one you can't imagine just how delicate a wood frame with fabric skin is. The Jenny flew at a scant 60 mph (maximum speed of 75 mph), was 27

feet long, and weighed only 1390 lbs empty. With a gas tank that held only 21 gallons of gas, the Jenny had a maximum range of a mere 150 miles. With such a short range, it was commonplace for a Jenny to be disassembled and shipped by ground to cover longer distances.

The Jenny is also the subject of one of the most well-known, and valuable, stamps in philately: The "inverted Jenny" stamp.

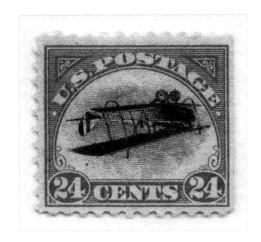

Charles A. Lindbergh

After WWI, hundreds of surplus Jennys were sold to the civilian market, including one to Charles Lindbergh as his first airplane.

As the story goes, in 1923, Charles Lindbergh drove to Souther Field in Georgia (now known as Jimmy Carter Regional Airport) with $500 he had saved from work as a wing walker for a flying circus. Souther Field was auctioning surplus Jenny's, and at the time had a hanger full of over a hundred crated Jennys from which to choose. Lindbergh bought a surplus Jenny JN-4 with a brand-new OX-5 engine, a fresh coat of olive drab dope, and an extra 20 gallon fuel tank for $500. Over the next week, Lindbergh watched intently as his Jenny was assembled.

Once the job was done, Lindbergh took the plane out to the field and taxied around for awhile, getting the feel of it. Although he had some dual

instruction time to his credit, he did not advertise the fact that he had not actually soloed. After nearly dinging up the plane with an attempted takeoff, he taxied back to the hangar and asked an instructor to ride with him. A few hours later, the instructor exited the craft satisfied that his student would do fine but he suggested that Lindbergh wait until later in the afternoon when the wind had calmed. So later that day, in May 1923, with less than 20 hours of instruction, Charles Lindbergh took his first airplane, a Jenny, and with it made his first solo flight, above the cotton fields near Americus, Georgia.

Lindbergh damaged his Jenny on several occasions over that summer, usually by breaking the prop on landing. His most serious accident with his Jenny came when he ran into a ditch in a farm field in Glencoe Minnesota on June 3, 1923, while flying his father (who was then running for the U.S. Senate) to a campaign stop. It grounded him for a week until he could repair his machine. In October, he flew his Jenny to Iowa and sold it.

Amelia Earhart

Even Amelia Earhart learned to fly in a Curtiss JN-4 Jenny.

Earhart's teacher, Neta Snook, tells the story in her autobiography "I Taught Amelia To Fly" (1977). Snook herself, in 1917, was the first woman to learn to fly at the Curtiss-Wright Aviation School. In 1920, using her own surplus Canadian version of the Curtiss JN-4 Jenny (known as a Canuck), Snook took a job as instructor at Kinner Field in Los Angeles. On January 3, 1921, Amelia Earhart and her father approached Snook, and asked "I want to fly. Will you teach me?"

To learn to fly she accepted the frequent hard work and rudimentary conditions that accompanied early flying lessons. She chose to wear a leather jacket to fly, but aware that other aviators would be judging her, she slept in it for three nights to give the jacket a more 'worn' look. She also cropped her hair short in the style of other female flyers at the time. Later in 1921,

Amelia made her first solo flight, and it was said that except for a poor landing, the flight was uneventful. Amelia would earn her pilot license from the National Aeronautics Association (NAA) on December 15, 1921.

Amelia told her sister, Muriel, that she could foresee a day when the cockpits of planes would be covered, when they would be large enough to carry 10 or 12 passengers, and even when they would run on schedule as trains did.

Elinor Smith

Dubbed "The Flying Flapper" by newspapers that followed her every feat, Elinor Smith set aviation records for endurance, height, and speed at a young age. Charles Lindbergh saw her off in 1928 on her most notorious exploit—flying under four of New York City's bridges, and she was even named female flier of the year by her fellow pilots in 1930 over her main rival—Amelia Earhart.

And yes, Elinor too learned to fly in a Jenny. When she was only 9 years old (in 1921), Elinor flew with an instructor, and propped up with a pillow had learned to take the controls, (aided by wooden blocks attached to the rudder pedals of a Curtiss Jenny.) She soloed at age 15, and at 16 became the youngest licensed female pilot in the world, though she nearly lost that license in the bridge-flying stunt. Her pilots license was signed by Orville Wright.

From learning to fly in a Jenny to piloting the space shuttle - in 2000 Elinor became the oldest pilot to complete a simulated shuttle landing.

James Doolittle

James Doolittle, the first person to fly across the United States in one day, commander of United States air forces during World War II, and leader of the "Doolittle Raid" in 1942, also learned to fly in a Jenny.

Though this entry in the TRIP BACK IN TIME: Vintage Photo Album Series™ explores learning to fly 4 years *before* Charles Lindbergh first soloed in his Jenny, and 2 years *before* Amelia Earhart learned to fly in her Jenny, their experiences in the cockpit would have been the same. Edward Southard's vintage photo album documents the source of inspiration of our earliest pilots, including great aviation pioneers like Charles A. Lindbergh and Amelia Earhart. Edward's own description for each photo is included in *italics* below relevant photos, with any additional commentary by the author included non-italicized.

All photos in Edward Southard's photo album were taken in 1919. And in the spirit of all books in this Vintage Photo Album Series™, **NONE of the photos from Edward's vintage photo album have ever been published before.**

LEARNING TO FLY IN A "JENNY"
Letter excerpts by William Muir Russel
Featuring Edward Southard's vintage photos from 1919

Work has begun in earnest, and I must admit it is a more novel experience than I expected. We were ordered to report at the field yesterday at seven o'clock, which meant rising at 5:15 in the morning, and a hasty breakfast. Dressed in our overalls, we were at once set to strenuous mental and manual labor; taking instruction by lecture, and tearing down and assembling aeroplanes. The work is entirely new to me, and has to be done rapidly, but it is amazing how much one can learn by practical experience even without instruction. At twelve o'clock, a bugle sounds, which informs us that we can check in our tools and rush to a small cafeteria across from the field and stand up to a delicious luncheon of ham and egg sandwiches and a bottle of coca cola. I then crawl into one of the hangars and have a rest—that is, if I rush my sandwich.

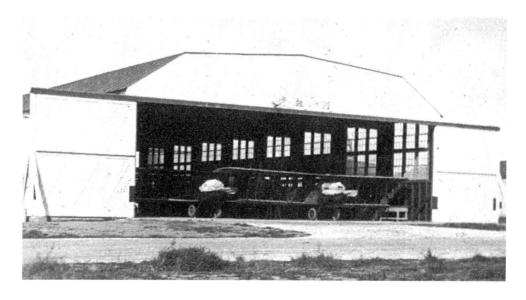

Another bugle at one o'clock, and we return to the assembling and repair department. Work then continues until four o'clock, when we are summoned for muster and inspection. At 4:30, we have drill for half an hour; then two or three times a week, a lecture on aero-dynamics. It may seem incredible to you, but I am enjoying work, and outside of a few aching bones, never felt better in my life.

I had dinner and a good visit with Jim Buckley the other evening. He has failed in his physical exam, for aviation on account of bad eyes. The average down here accepted is five out of twenty-four examined.

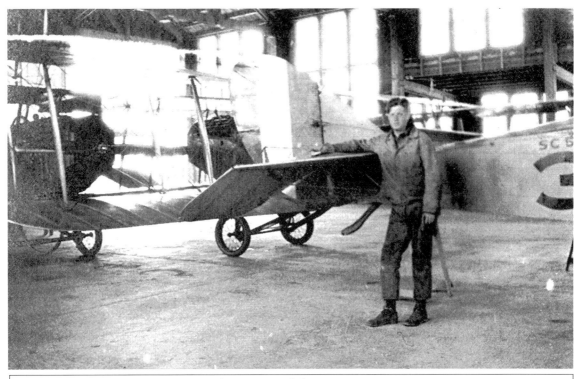

Dizzies work once in a while. Martin in a Hangar.

You will understand that it will take some little time for me to become accustomed to work, so I will not write you again for a few days.

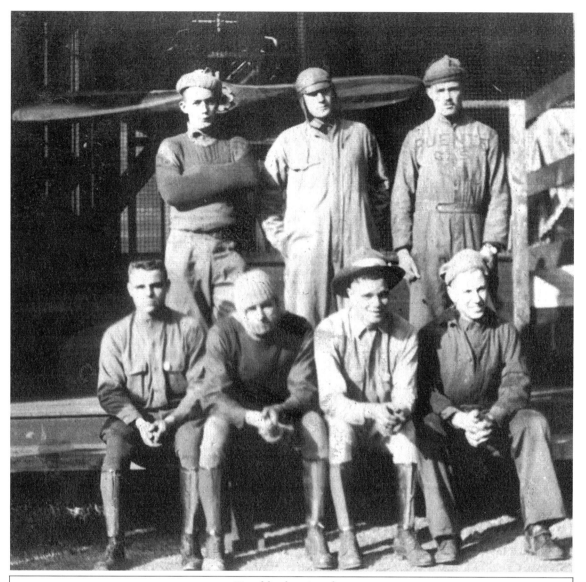

Trouble-shooting days.

Never before have I looked forward so eagerly to Saturday afternoon and Sunday for rest as now, at the end of the first real working week of my life. I felt, however, that such a breath from Heaven as a week-end rest was too good to be true. Sure enough, it was so.

The engine test stand.

My work during each day has been practically the same. To prove how strenuous it is, it will probably surprise you to know that I have been in bed

every night by a quarter of nine, with the exception of Sunday night guard duty. I have, however, been placed on the flying list, which means that I have a flight every day, weather permitting. My first ride was what they call a joy ride. You merely sit and endeavor to accustom yourself to the new sensations. From now on, I will be permitted to drive with the instructor at another set of controls behind me to correct any fault. It is hard to describe the feeling. At first it gives you very peculiar sensations in your stomach and ears. One thing that surprised me was the roughness of the riding. Looking at an aeroplane from the ground, it seems to glide, but the riding in the aeroplanes in use here is very rough and choppy. It may be a consolation to you to know that I have been assigned to an instructor who is said to be the most conservative flyer on the field.

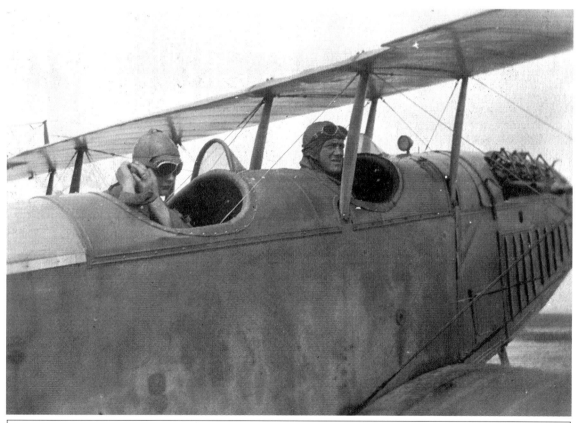

Dan Furbur and Lt. Golliver

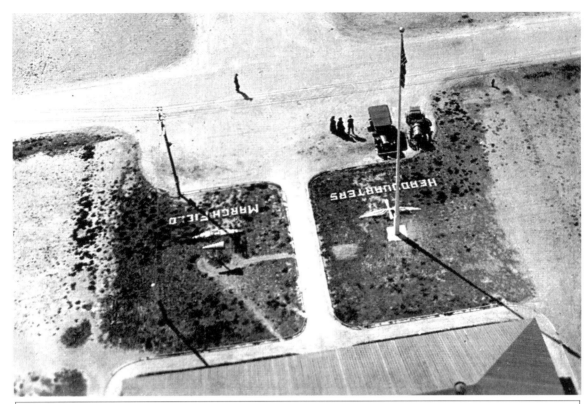

Sent to March Field for flying instruction, Riverside, California. Headquarters from the tower.

My second inoculation for typhoid yesterday gave me no fever. I returned to my room, waiting all afternoon for evil effects to come, but instead of that, I felt better and better. This morning, I wakened at the usual early hour, and felt so good that I did not take the rest of my 24-hour leave, and reported to the field. It was a mistake, because I found about the busiest day of my short enlistment experience awaiting me. Two other men and myself tore down two entire machines and packed them for shipment.

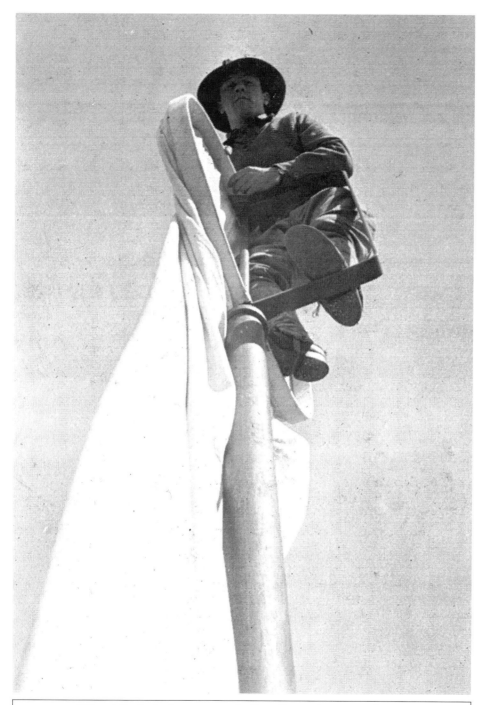

"Shortie", the lookout on top the Beaufort scale on top of tower.

One young fellow came here, entered the aviation school, and has been placed under guard, and removed from the flying list because he cheated in an examination. Although he is still in the camp, he will probably be dishonorably discharged. Captain Royce gave us a good talk on this subject yesterday, and told us the way it was dealt with at West Point.

In comparison with an automobile, it has been surprising to me how simple the construction of an aeroplane is, and the rapidity with which it can be set up and torn down.

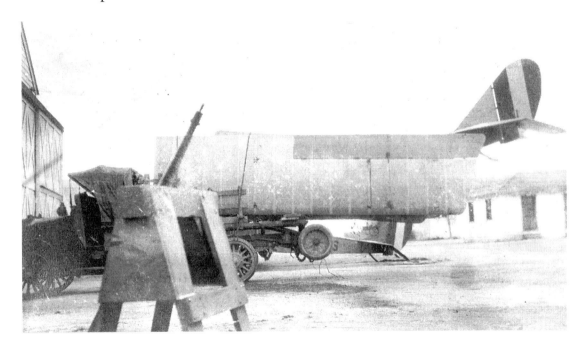

The last two days have been beautiful—the air clear and still. Ten to fifteen machines have been in flight nearly all the time. You cannot imagine the difference between flying at Memphis and here. At Memphis, we had a small field with heavy woods on one side, where naturally the air was cool and descending rapidly, while on the other side was a lumber yard, on which the sun beat down heating the air, and causing it to rise. On a field of this kind, you can imagine the bumps you hit as you cross from the ascending air into the still air, and then into the descending air. On the

other hand, the field here is a mile square, and the surrounding country open, and of the same level, which causes the ride to be a gliding motion, perfectly smooth.

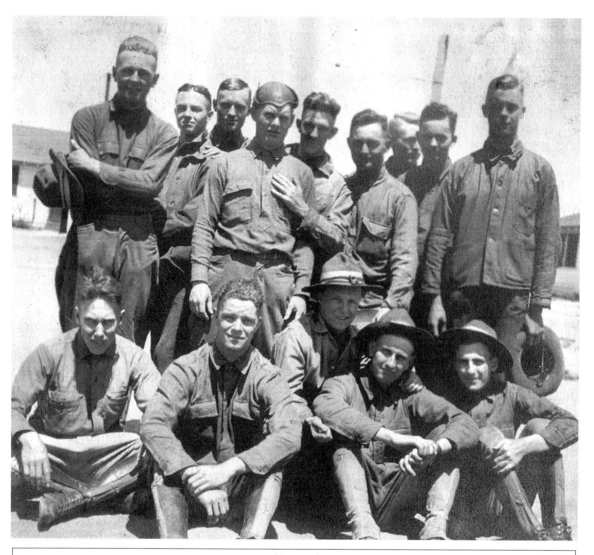

'Dizzies'

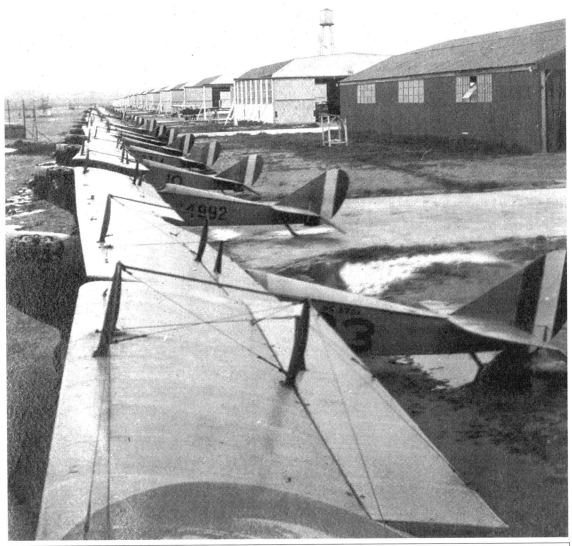

On line for inspection.

Yesterday, six new machines arrived, the first of a bunch of eighteen which have been ordered for this field, making forty-eight in all. They are standard aeroplanes, manufactured, I think, in Plainfield, New Jersey. The same type of machine is used at Mineola.

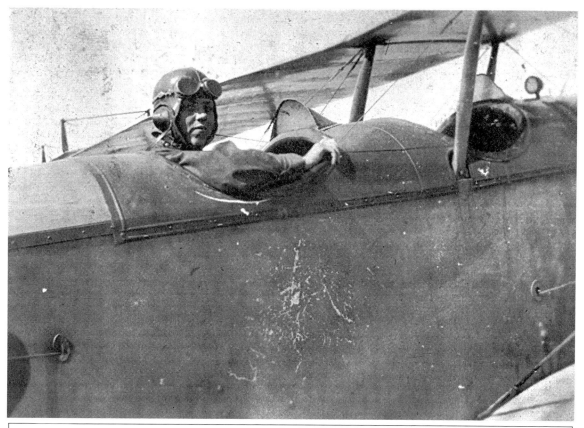

Warren F. Lamb, Los Angeles, Calif.

Work has been progressing, although slowly. Since our bad storm the other evening, the weather has been better, and the ground is drying out very rapidly for such a marshy place. The machines are being set up, and by the end of the week, we ought to have all forty-eight in commission. The new machines show beautiful workmanship, but as yet we have had none of them in the air. Some of these machines, we expect, will be equipped with the new "stick" control. We are informed that we will have to learn its use—that is, instead of using a wheel to guide your elevators and ailerons, you use a rod or stick, which you work sideways and forwards and backwards to govern your movements. This control is used almost entirely on the French and British machines. It can be more rapidly handled with

one hand, leaving the other for the gun and the different manettes. Now, we are taught to hold the steering wheel at the top center and guide it with one hand, and thus practically follow the same motion as with the stick.

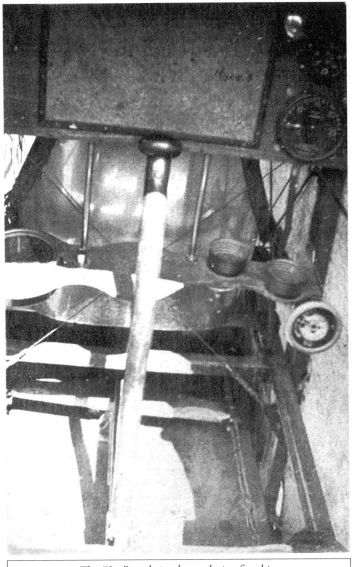

The "Joy" stick in the cockpit of a ship.

Yesterday, the Speedway races were held for the benefit of the Red Cross fund, and to co-operate and add to the interest, our field was asked to fly over and

descend on the Speedway. Only instructors and advanced students were allowed to take part in the flying. It was a mighty pretty sight to see the fifteen machines go skimming through the sky and coiling down, and then drop one at a time into the field. Mr. Boyer will be interested to know that his son Joe drove a very pretty race up to the 150-mile mark, when he was forced to withdraw on account of engine trouble. His running mate, the famous Louis Chevrolet, did not make as good a record. The day was perfect, and they had a good crowd of sixty thousand persons, a very successful show for the Red Cross.

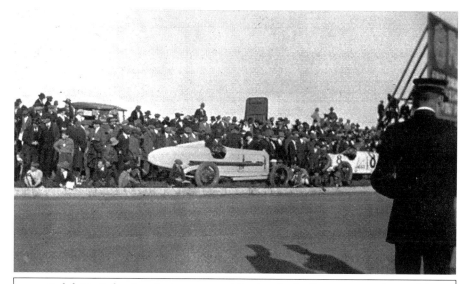

Ralph DePalma's aviation motored Packard, the fastest car in the world
Santa Monica road races, 1919.

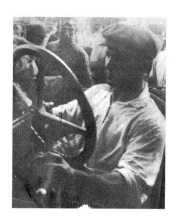

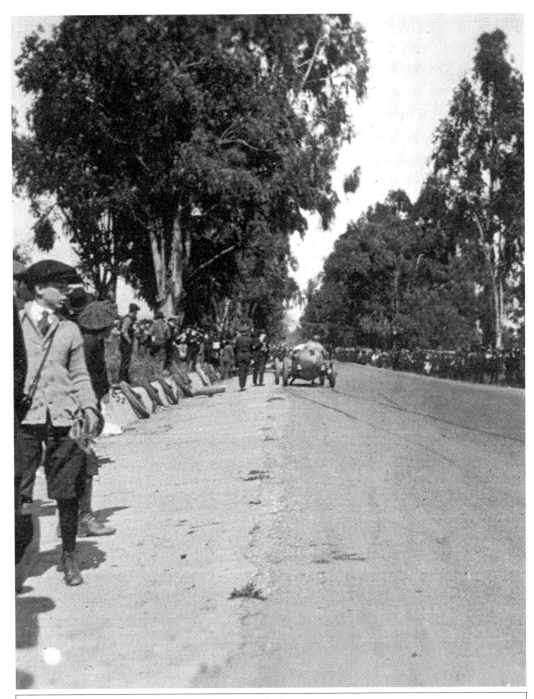

A quick change.

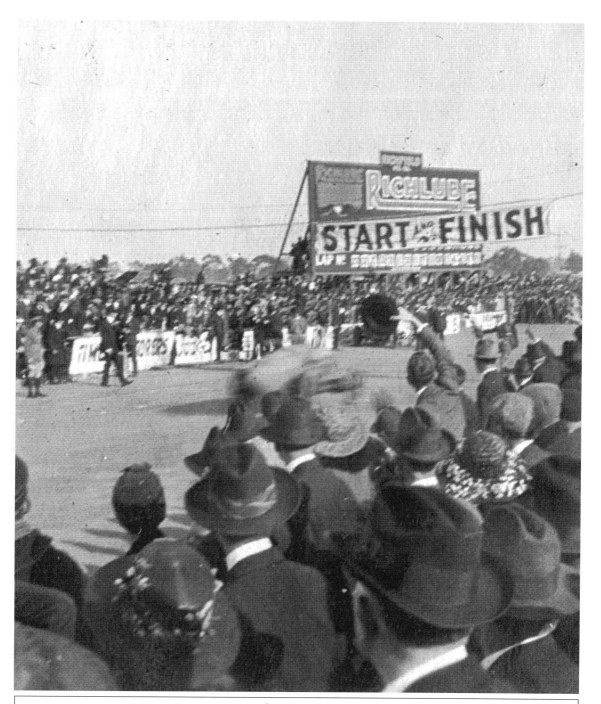

Durant wins!

The last week has been so perfect, and so much has been accomplished, that I feel as if I had a new lease of life, and am more enthusiastic about flying than ever.

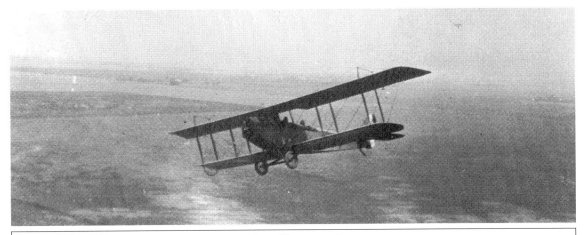

Get off my wing!

The sun has shone all week, and, as a result, the ground has thoroughly dried out. Last Monday, I made only one flight, but on each of the remaining days, I have made two. With this long consecutive run, I have at last got some confidence in myself, and yet, at the same time, I feel how little I really know. The flying in mid-air above an altitude of two thousand feet is comparatively simple. The quicker action and decision is required as you get nearer the ground. I should say that, barring such accidents to an aeroplane as might happen to an automobile, a locomotive, or even a carriage, from a concealed defect, or the breaking of a part, a fellow is safe when flying at a height of more than one thousand feet; between one thousand and five hundred feet, he is reasonably safe; at less than five hundred feet, there are elements of danger. You cannot rest even in a straight course as with an automobile. Each little puff of wind swings you to the right or to the left. The early morning flight, however, is very different. The air usually is perfectly quiet, and you glide along like a bird. My instruction last week consisted practically of straight flying, with occasional turns. The early part of this week, I spent

in making left hand turns in the form of a circle or square. On Wednesday, I began on right hand turns, which are very different from the left hand ones. This is due to the revolving of the propeller, the tendency being not only to turn your machine to the left, but also to upset it laterally to the left. This must be prevented by giving it right rudder and right aileron more than left, thus holding your machine in a stable position. Seven machines have been somewhat damaged this week on account of too steep a descent before landing. The ground is still somewhat soft, and the front wheels stick in the mud, which throws the tail up in the air, and causes the machine to stand on its nose, and smash the propeller. Ordinarily, it is not very serious, but rather a nuisance, as it puts the machine out of commission for some time.

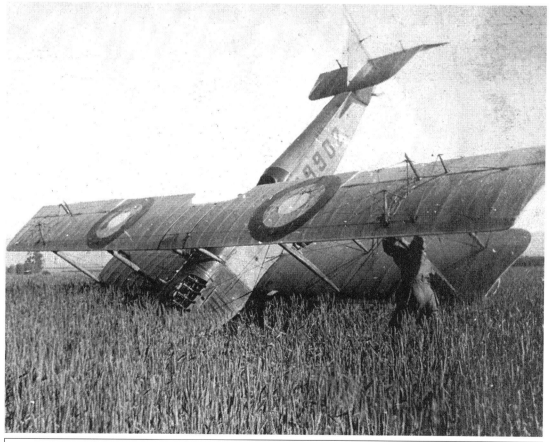

The Daily Mistake. Lt. Van Zant's crash.

Aeroplanes now are plentiful. We have forty-eight for the use of seventy-three students. One of our most advanced men, who was already recommended for his commission, has been indefinitely suspended for looping the loop with a passenger. In the first place, it is strictly against the rules for a student to loop the loop without permission of the commanding officer, and secondly, it is forbidden except for an instructor ever to loop with a passenger.

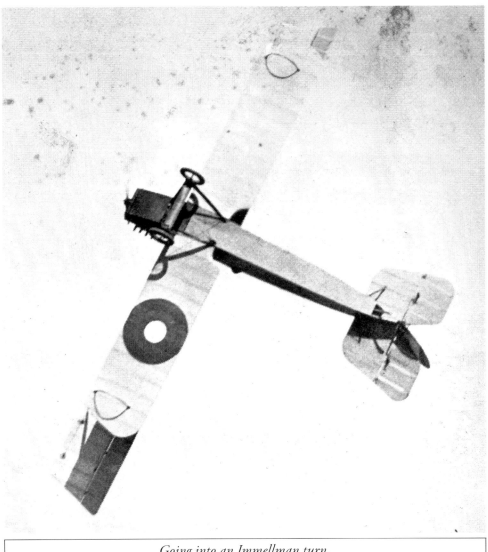

Going into an Immellman turn.

Saturday ended by far the best week yet of my training. The good weather brought new life to everybody. We now have practically all of the planes set up and in running order. In addition to our forty-eight machines, there are six private aeroplanes. I have been able to get eleven flights since last Monday, and in that many one can accomplish a good deal. I have become perfectly accustomed to the new and rather pleasant sensations, and yet the various flying movements seem as strange and unnatural as ever. On this account, I sometimes feel discouraged, but they tell me the faculty comes to you over night. At any rate I am pinning my faith on this.

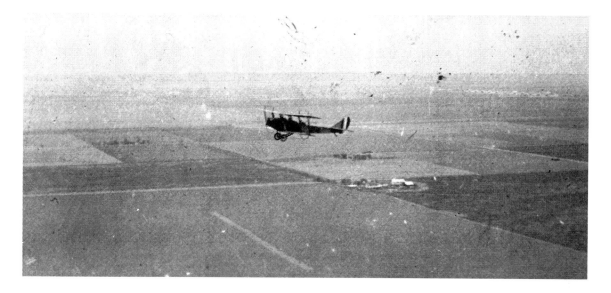

The landings still look impossible to me, but as I have not tried to make any yet, it is no wonder.

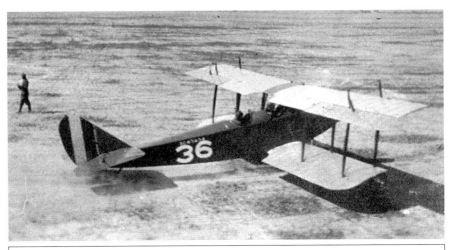

The first ship I ever flew in.

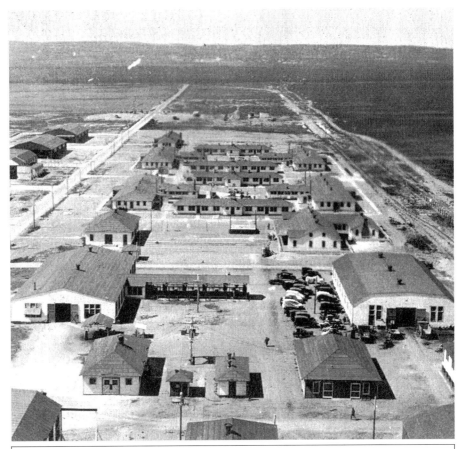

Detachment Head-quarters, including the west end of the field from the tower.

The delightful weather of last week did not last. This week it has gone to the other extreme. Monday was the only day I could make a flight. The rest of the time the rain has beaten down, and the field is practically lost to the eye under four inches of water.

Shortly after my flight Monday, all flying was stopped on account of a nasty accident to one of the solo men, who escaped miraculously from a wreck in a tail spin. This is a form of accident which a novice aviator must always guard against. It is usually the result of carelessness or a moment's forgetfulness. From the minute you first begin instruction, you are warned about it, and told how to keep out of it. A "tail spin," as it is called, is caused from losing headway. It results from two factors—failing to nose the machine down on the turns, and failing to keep the direction of the wind clearly in mind. On making a turn, if you do not nose the machine towards the ground, you necessarily lose such headway that the plane becomes uncontrollable. The nose will drop on account of the weight of the motor, throwing the tail into the air. If the wind is coming from a side direction, it will strike the plane, whirling the tail, and tend to spin it around the nose as an axis. Your only chance to gain control is to head to the ground with the motor off and the rudder held against the wind until you gain sufficient headway to get control once more of the machine. If you are at an altitude of over five hundred feet, your safety is assured, otherwise a wreck is imminent. This boy kept his head remarkably well, and never ceased fighting to gain control. When they got him out of the wreckage with only a couple of minor cuts on his face and a bad shaking up, they went over every part of his machine. It was badly smashed, but the controls were all in good condition. He fell about two hundred feet, and in that small space of time he had removed his glass goggles, unfastened his safety belt, throttled the motor, and shut off the spark—the four things he should have done. As I said, after this accident, all flying was called off for the rest of that day, and for the remainder of the week, it has poured rain.

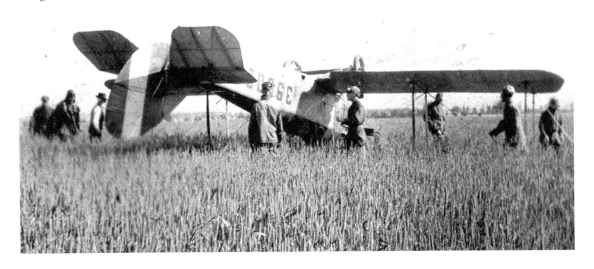

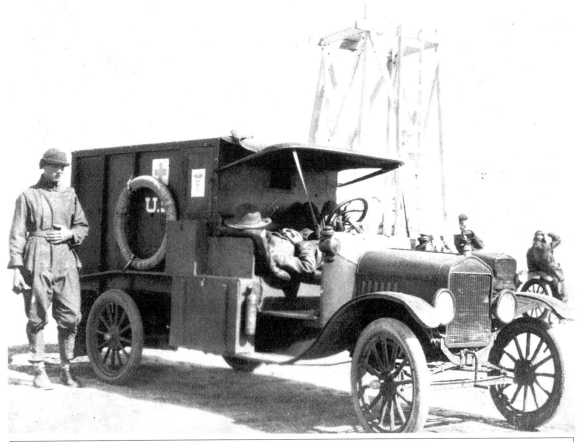

The *"Meat Wagon" always waits.*

Another rather unfortunate experience of a different kind has come to one of the boys, a nice fellow, this week. He entered just about the time I did, and it has been evident that flying did not appeal to him. All the time he struggled to overcome his aversion to the new sensations, but somehow, they were so unnatural to him that he failed to master his feelings. Wednesday, he went with tears in his eyes to headquarters, and after a long talk with the Captain, was released from the Aviation Corps. He was a brave enough fellow, and wanted to continue. This is the second case we have had. It seems that one's feelings are not controllable. You are either fascinated or dread it.

Tomorrow, we will have inspection here by a board of officers from Washington.

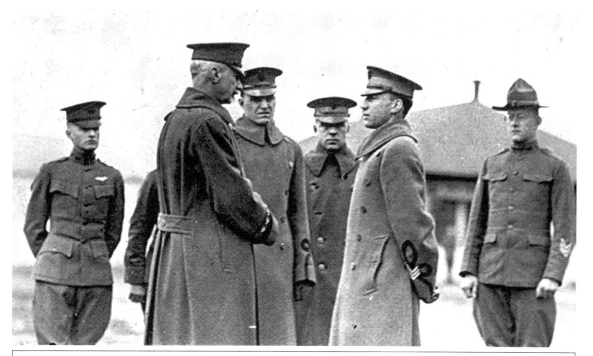

Gen. Peyton C. March (whose aviator son was the namesake of March Field),
Maj. Peabody, Maj. Bartolf-in charge of post, Hightower-disciplinary officer.

During this rainy spell, all the planes have been put in good running condition, and the extra time consumed in putting a polish on. I suppose that you have heard that the Curtis Aeroplane Company has been reorganized and new equipment has been installed so that it is said they can make five thousand machines this year.

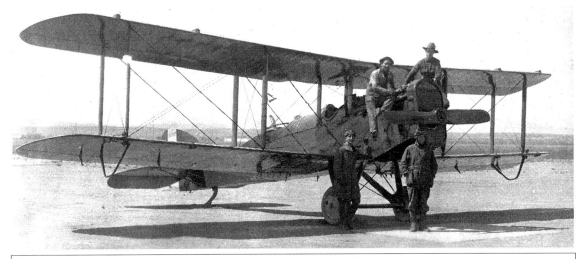

My best ship. Blue-Bird.

Saturday, we leave for Rantoul. They say that there is no better flying field in the country. A concrete foundation, covering about forty acres, has been laid so that we will not have the trouble and danger of either starting or landing on the wet, soggy ground.

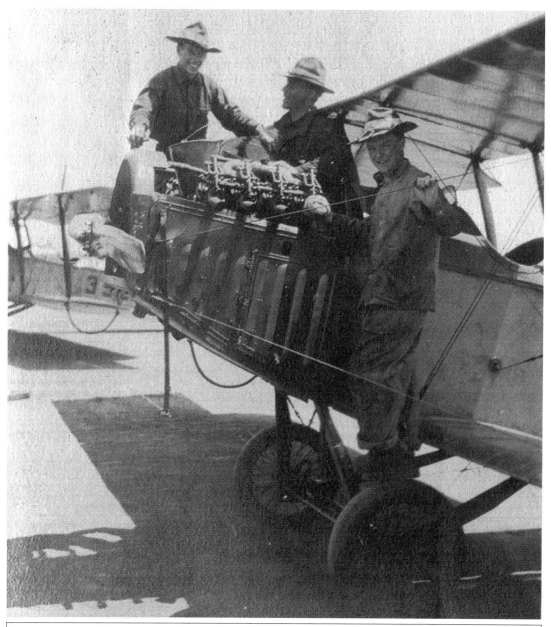

My aerobatics class: Whitmer, Woode, Ramsey—the other aerobats.

Saturday noon, thirty-eight machines, each carrying two passengers, will rise at short intervals and fly in a line. It will be a novel movement in American army experience to transport a corps in this way. I think I will be

permitted to be a passenger in one of the planes, Mr. Pond's, and if so, he will probably let me drive it all the way down. This will be considered extra time, and not marked against my instruction hours. The other ten machines will be torn down and shipped by freight.

Barracks life will be new to me, but I feel sure it will be preferable to the haphazard way we have been living. It will save an hour or two's time in the morning, and instead of grabbing breakfast and rushing to a train, we can have a snappy setting up exercise and a peaceful breakfast afterwards, and so much the more flying; lunch at 11:30—a thing we have not known here—will be served; one o'clock another roll call; two o'clock, an hour of drill; three to five, recitations in aero-dynamics, practical electricity, and meteorology; five to seven, two more hours of flying instead of a tramp or run to the junction and a ride on a freight train, and a scramble on a crowded trolley car—then supper and bunk (I mean bed, of course). A new commanding officer, Captain Brown, I understand, will be in charge of the post, with three French aviation officers. I had the good fortune to go in with them from the field today—Lieutenants Gauthier, Laffly and La Pier. The latter, I am told, has twenty-eight German planes to his credit. They will conduct the courses in military science of the air. One of the many interesting things I learned was that their fighting machines can travel at a speed of one hundred and fifty miles an hour, with a landing speed of ninety miles an hour. Contrast this with our maximum flying speed of eighty miles and a landing speed of forty miles. You will appreciate how little we will really know, even after we have received our complete instruction on this side. He told me, too, about Guynemer, the great aviator who has forty-nine German machines to his credit. He said that Guynemer, as an aviator, was only a mediocre flyer, and that his great success lay in his daring and remarkable marksmanship, often bringing down the enemy plane with one shot.

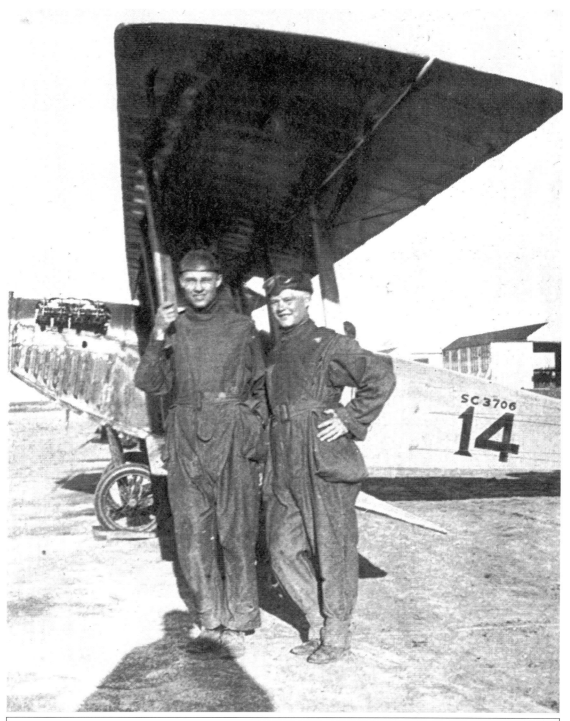

Gunderson and Texas

It was rumored, but not definitely known, that we were leaving Ashburn, until just before an order came to set the machines in perfect condition to be prepared to fly to Rantoul at five o'clock next morning. So after working from seven until five on Saturday and Sunday, we left for Rantoul at ten o'clock Monday morning. Everyone wanted to take an aeroplane, or go as a pilot, but hopes were shattered when word came that only instructors and advanced students should fly, and that each should be accompanied by a mechanic. So on account of the method of assignment, the solo men took the remaining planes, either as drivers or passenger mechanics—then the civilian mechanics filled the remaining cars. Practically all the students were left out, and I missed my chance to ride. It would have been quite an experience, as well as good training, to fly cross-country for one hundred and fourteen miles.

It was a wonderful sight to watch the departure of twenty-five machines, in the early morning, as they rose from the field, one closely following the other, circling their way up to an altitude of three thousand feet, and in a V formation, two minutes apart, strike south, following the Illinois Central tracks. The first machine covered the distance of one hundred and fourteen miles in eighty-six minutes, and the remaining machines dropped into the field at Rantoul within thirty-five minutes after the first. They averaged about eighty miles an hour, and dropped into the field in the same order. The entire trip was made without a single mishap with the exception of one machine only, driven by Mr. Pond, my new instructor, who was forced to land in the town of Kankakee for gasoline. In starting his motor again, the mechanic did not get out of the way of the propeller quickly enough, and was slightly hurt. Aside from this small accident, the trip was made with a clean record.

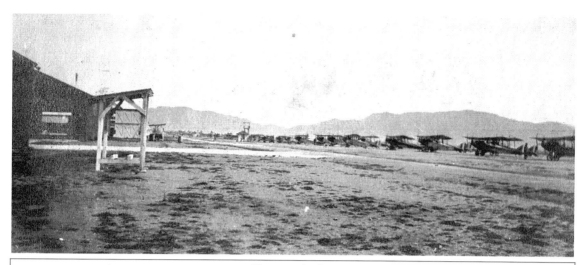

Ships on the line.

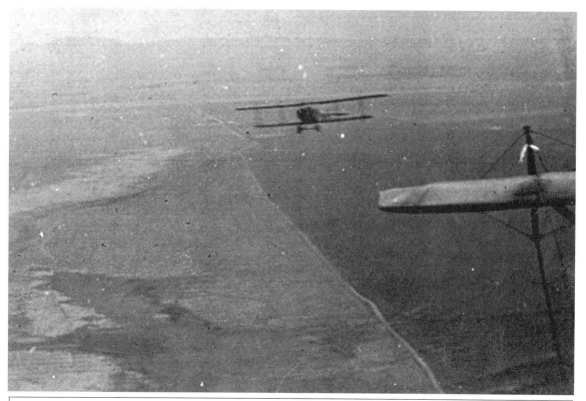

Lt. Kate follows Guillet.

The trip, for the rest of us, however, was not so pleasant. We left Ashburn about 10:30 in the morning, and wandered over the tracks at a slow pace, covering the hundred miles by 10:30 in the evening, with practically nothing to eat all day. In a hot, stuffy coach, you can imagine how happy and congenial the crowd was when at last we ran into Rantoul. Even the reception which awaited us—the entire town assembled in Sunday clothes, ginghams and overalls, with a band of music, waving flags, and a kind greeting from everyone, old and young—did not cheer us into amiability.

To tell you something of the location—the field is situated on the edge of a small town, in the levelest of level country. For the purpose of a flying field, it cannot be surpassed, and although not quite complete, is in good condition for use. On one side is a row of huge wooden hangars, each with a capacity of six aeroplanes. Behind the hangars is a row of sixteen very good new barracks, each with a good bathroom and shower. Behind the barracks are the mess halls still under construction, and next the officers' quarters. Scattered about are other buildings for Headquarters, Y. M. C. A., motor house, and repair houses. Excellent roads and paths wind in and out among the buildings, and the grounds beyond have been laid out. The buildings are all white, and mark the field from a long distance. It is an ideal location for concentrated instruction and flying, and we will have far more flying hours than before. Seventy-two machines are expected within three weeks. I think we will be able to have instruction in any kind of weather.

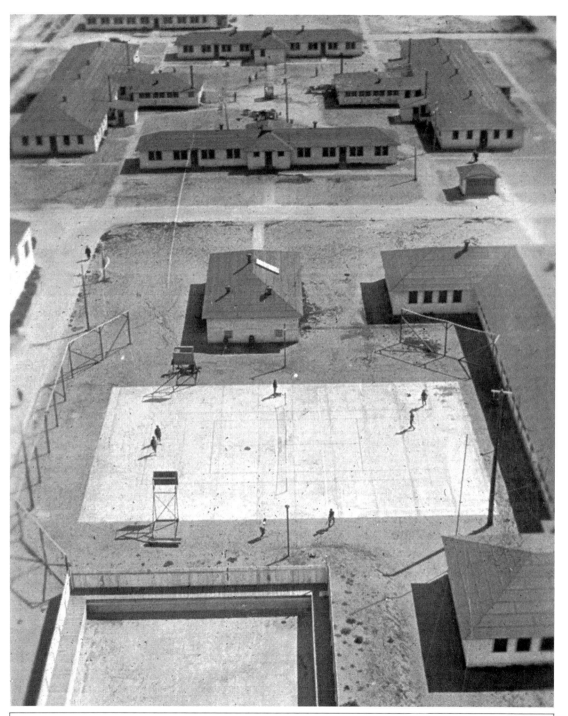

Cadet barracks, school and playground from the tower.

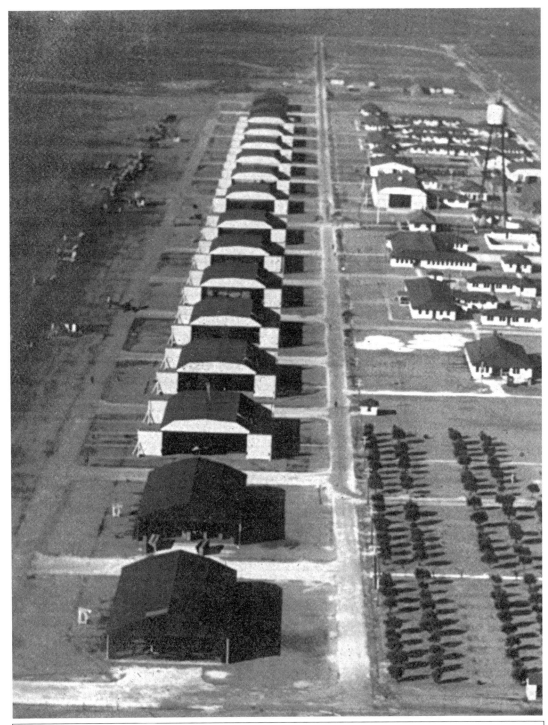

March Field.

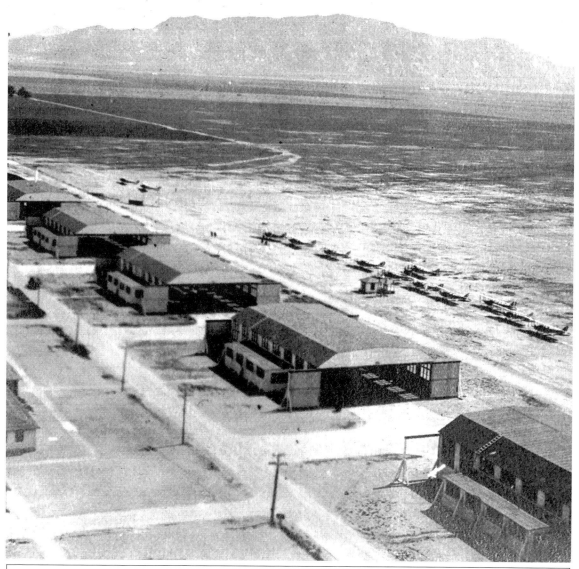

East end of field from the tower.

You may be interested in our methods of training. You are set directly to flying after the first day, when you ascend for a ride to accustom yourself to the new sensations. This is called the "joy ride." From then on, unless there

is some natural defect or personal characteristic which prevents, the controls are given over to you, and you drive the machine under the guidance and aid of another set of controls operated from the rear seat. On becoming more proficient, you are put in the rear seat, and later you are sent up alone to do solo work. After twenty hours of solo work, you are allowed to undertake your flying tests for a commission. I am just about to be turned loose; that is, to begin solo work. If we have good flying weather, it will require about five weeks more training.

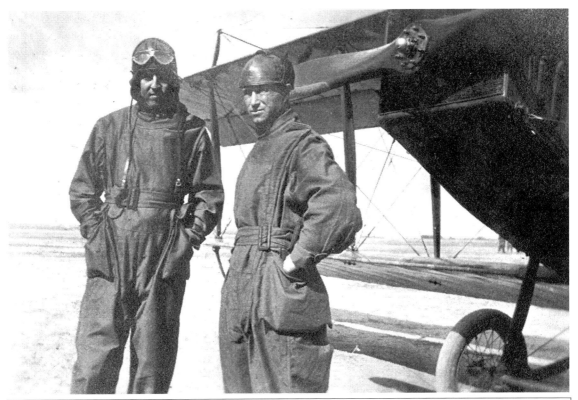

Murray and Wheeler.

Our day's work is well laid out for us, and we have little time for recreation. We rise at 5:45 in the morning, have a good setting-up exercise, and a fair breakfast, then we are set directly to work with the machine crew. Six fellows have charge of the upkeep of two machines. When your

turn to make a flight comes, an orderly notifies you, and you take half an hour in the air. At eleven and twelve o'clock you report for classes in aerodynamics and practical electricity. Noon mess is usually a light meal. In the afternoon, we have military drill, class in meteorology, and the remaining time in the motor room where we tear down and assemble motors. The evening is usually spent in study, preparing for the final examinations by which our commissions will be ranked to a certain extent. The work of the Administration in this branch of the service, it seems to us, cannot be commended too highly. Business men have offered their services freely and willingly to aid the production end of aviation in the most efficient manner. Many aeroplanes are being turned out, and training schools, fully equipped, have sprung up in six weeks' time.

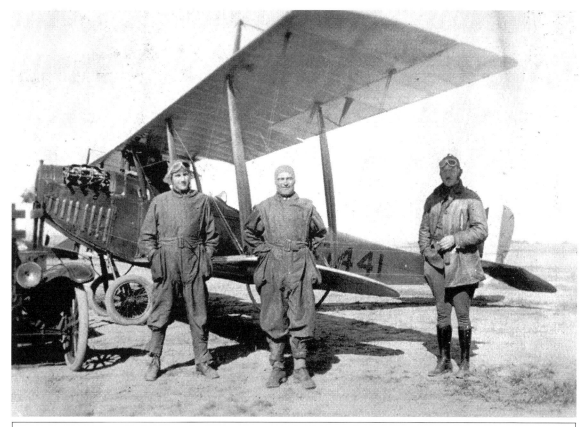

Buttner, Noonan, Lt. Green; 1ˢᵗ ship I received instruction in.

Monday, we resumed systematic flying, and the weather has been ideal until today, when it was very rough. I have been able to get my thirty minutes each day, and really begin to feel like a regular aviator, even if I do place a lot of faith in that young man in the front seat who can set me right if I go wrong. It seems, sometimes, as though I would be lost without him. They tell me that you never get real confidence until you have made some solo flights.

Today was a Jonah for us. In the afternoon, ten of the more advanced students tried their Reserve Military Aviator tests, with some disappointing results. Nervous, but determined, they all started off brilliantly. The first test was to climb to an altitude of four thousand feet, and remain there forty-five minutes, then descend into the field and land within one hundred and fifty feet of a designated stake.

The first, in descending, misjudged his distance, rolled by the pylon, and bumped into another machine. The Captain was wrought up, and he had hardly turned away from the wreck when the second machine crashed head-on into a pile of lumber. The boy's head was thrown forward, hitting the cowl, and he was badly bruised about the face. A remarkable incident of the accident was that he did not have time to remove his goggles, and when his head was thrown forward, they struck the celluloid wind shield, and were broken. Just before going up, he borrowed a pair of triplex glasses from one of the other boys. The glass in the goggles was cracked into a million sections, and not a particle splintered. This triplex glass is a safety device either of mica compound or glass between thin strips of mica. If you can find a pair in Detroit, Boston, or New York, please buy them for me. They are quite expensive, and, I understand, nearly all in this country have been sold. Get a large field of vision—the small ones are not useful. I am enclosing a sketch of the best size and shape.

Gunderson, U of SD, by himself.

Now for more trouble. Not fifteen minutes later, two machines came down, and nosed over, breaking the propellers. This is caused by the wheels sticking in the mud or a rut, which throws the tail up and tips the propeller into the ground. Usually nothing more serious happens than to put the machine out of commission for a while.

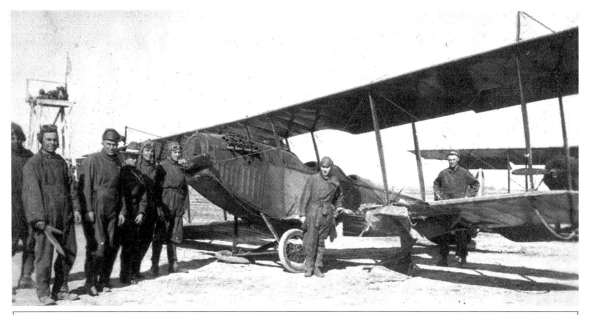

Bostwick's crash.

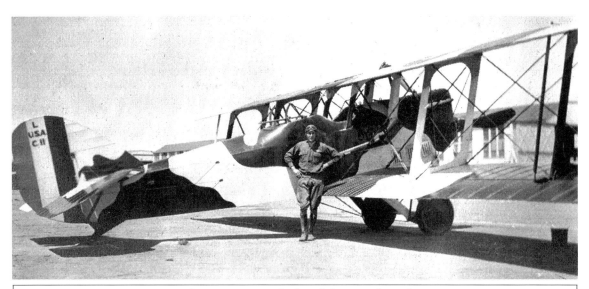

Buttner by a La Piere—the best fighter made in the U.S.

The two French officers who have been stationed here are both fine and interesting fellows. They think that our machines, the Curtis, J. N. 4 B., are the best training machines they have seen, and say that when we go to

Europe we will have to learn how to fly four different types of machines, including the monoplanes. They have not yet become accustomed to flying our machines, and they have given very little exhibition flying.

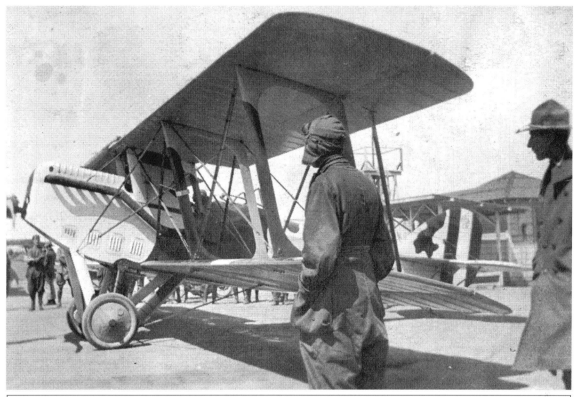

La Piere that visited our field the other day.

The purpose of coming here, namely, flying, has been well met. The weather has been ideal, and great progress has been made. I have had a thirty minute flight every day. The training has been slow on account of frequent removals, but at last I am getting to the end of my preliminary instruction. For the past few days I have been working on landings, which is the final step. Next, solo work, or flying alone, begins in preparation for the Reserve Military Aviator tests. If these are passed, my commission follows automatically.

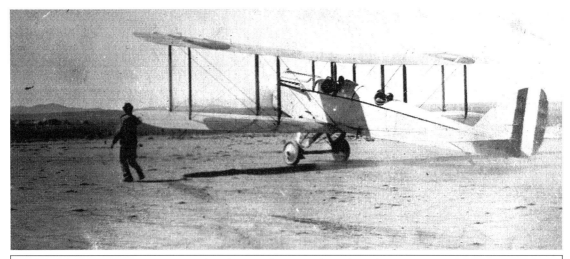

The Blue-Bird taxiing for take-off.

The work becomes more fascinating each day, and as instruction continues, you realize that flying is a science with something more always to learn. A person can easily learn enough in one week to fly in the air, but without more experience, he would lose his confidence and have an accident at a critical moment. This has been evident during the last few days. Many of the boys became impatient, and induced their instructors to turn them loose for solo work. Friday, we had four accidents, none of them serious, but the machines were wrecked and the boys pretty well bruised up—all due to ignorance and inexperience in the pinches. Then Saturday, one of my room-mates was sure he could make a good landing. The controls were turned over to him by the instructor, and when he came down he was sailing against the wind at an air speed of about seventy miles an hour—that is, going at the rate of fifty miles against a wind of twenty. In flying, you calculate your speed with the air and not the ground, as it is the pressure against the wings which does the lifting. So when he rounded the last turn to alight in the field, the twenty miles wind pressure was taken away, because he was then flying with the wind, and not against it, and the air speed was reduced to not more than forty miles an hour, which is below

the necessary minimum. The machine went into a tail spin at an altitude of about 200 feet, and the wind caught the tail of the machine and spun it around too near the ground. They were dropping down into the field from a high altitude on a long glide, and lost too much headway. Both kept their heads remarkably well, and if they had had fifteen feet more in which to drop, they would have avoided the smash. They straightened out just enough to break the fall, and when they collided with the ground, their life belts held their bodies firm, but their heads were thrown forward against the cowl. Both occupants were taken from the plane and given up for dead. On examination, however, to our great joy, they were found to be badly cut, with one nose broken and faces disfigured the score, but luckily without permanent serious injuries, although the machine was a total wreck.

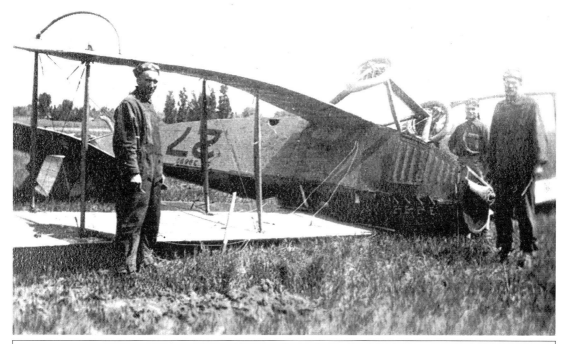

Freman's crash. Turned too close to the ground.

I wish I could explain some of the ways of getting into a tail spin, but am too young in the art yet, and it is difficult for me to describe it. Even

with a perfect machine, it is only one of many dangerous situations which may come at any minute. A flyer must know how to avoid them if possible, and to counteract them if necessary.

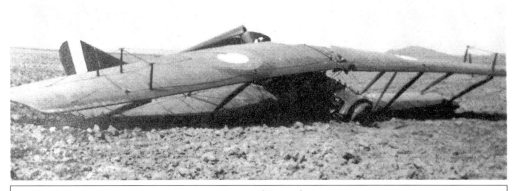

Sgt. Frank's crash.

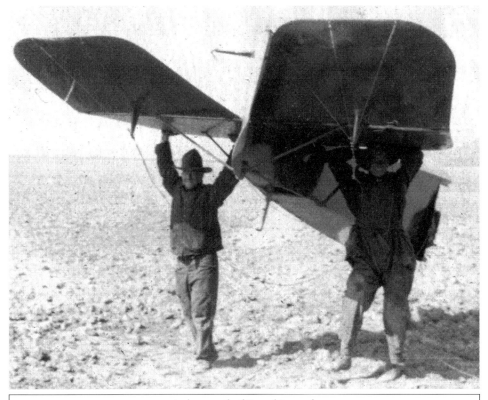

A short tail of Frank's crash.

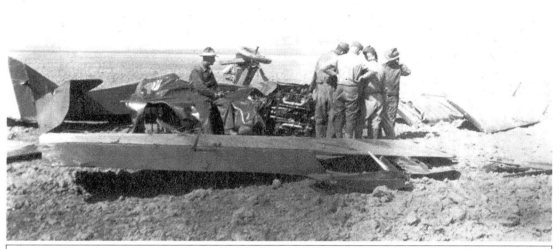

Sgt. Frank's crash. A coat caught in the controls.

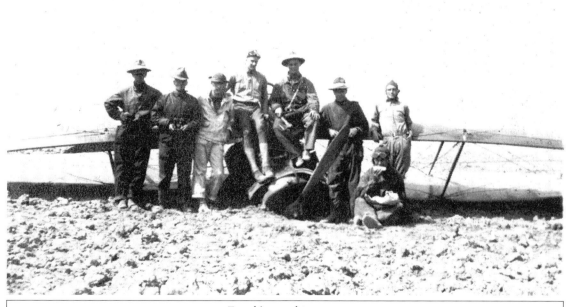

Frank's wrecking crew.

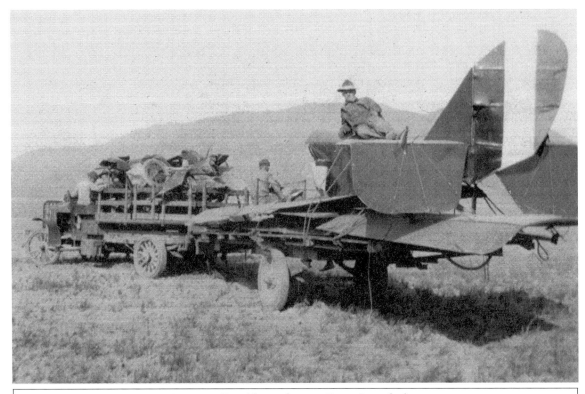

Bringing Frank's machine to Davy Jones locker.

Good news was the coming of ten new Curtis planes yesterday. This will give us a chance for more instruction, which, however, is progressing rapidly now. I have reached the step where I am making landings. This is a difficult part of flying, and to a considerable extent, the phase by which you are judged. It is no easy thing for me yet, but I am sure I will soon get the knack of it. My instructor said yesterday that my air work was tip-top, and that I was coming on with the landings. Tuesday and Wednesday, I practiced gliding into the field from an altitude of two thousand feet. That was easy, but when we got about one hundred and fifty feet from the ground, he would take the control and make the landings. I would then ascend, and we would do the same thing over and over again. The purpose of this is to practice your spirals so that you will enter the field from the right side and always against the wind.

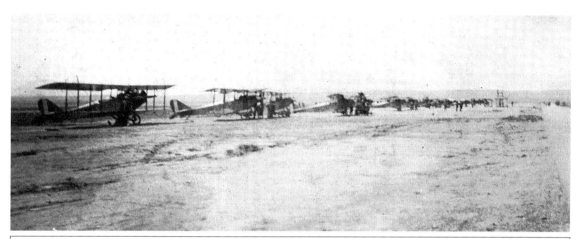

Ships on the line.

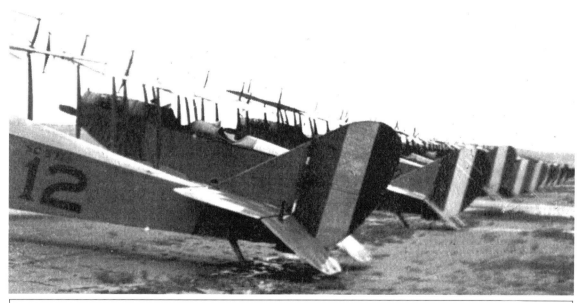

On the line for inspection. No 12 is the only ship I got sick in.

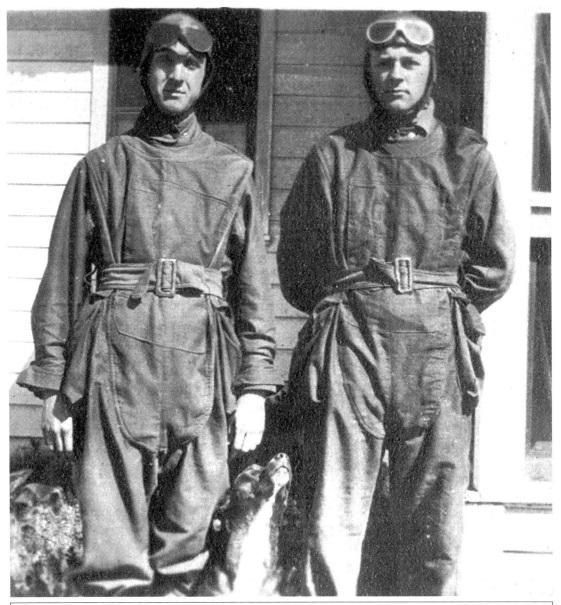

Clark M. and Ray Willson, "Contact" the camp mascot between.

I have at last had an aeroplane put under my supervision, for which I am wholly responsible, and which is also my own instruction machine. This puts an incentive up to you for careful work, as your neck depends upon your own diligence.

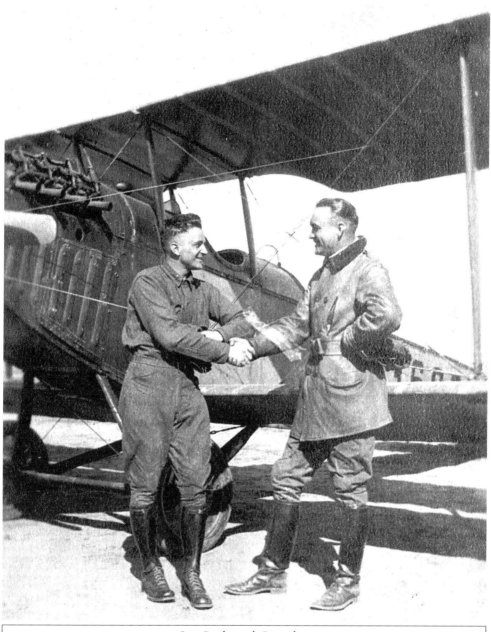

Lts. Baily and Coumbus.

A package has just come from Aunt Jennie and Aunt Chris, containing knitted helmets, which I am told will be very necessary when the weather becomes colder. I have never worn a knitted one yet, and it does not seem at

present that I would ever want one. The weather is roasting, and we have to work all day in the broiling sun with heavy flannels and woolen shirts.

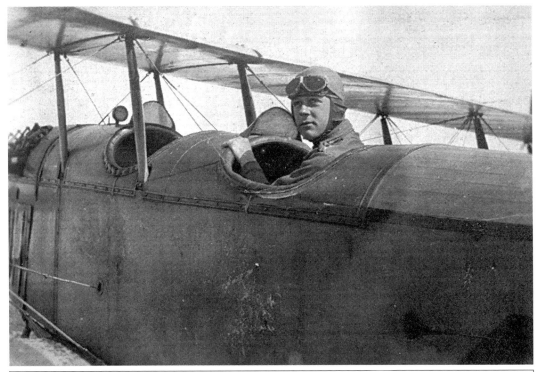

Ray Willson.

The last few days have been exceptionally busy and terribly hot.

My flight today is last on the list, and my machine is running like a bird, so that I have a few minutes for a breathing spell and retreat from the burning sun. Monday morning, when I began instruction, we had a very poor machine, and the air was rough. I have told you accidents usually occur if you lose headway near the ground, either on the first turn in ascending, or the last turn in descending. The predicament we were in Monday was a perfect setting for such trouble. In climbing from the field with a motor which was not working too well, we could not get enough altitude, and had to take the first turn when only seventy-five feet in the air. Mr. Pond, my instructor, was watchful, as he always is, and grasped

the situation and took the controls from me, and dropped into the field with the wind, something that is never done except in emergencies. We landed all right, but he refused to go up again until the machine was fixed. I worked on it for more than two hours—changed the propeller and some other minor things—and then called Mr. Pond. He then tried it alone, but found it unsatisfactory, and condemned it. This put me to work for the day. It meant that the entire motor had to be removed from the fuselage, and another set in. Allen Wardle and I tackled the job, and we have since been working and sweating steadily—Monday night until eight o'clock, and last night until nine. This morning, we tried her out, and found her satisfactory. She will turn over thirteen hundred and twenty-five revolutions a minute—twenty-five more than the mark. This, of course, is on the ground. In the air, she will turn over about one hundred better.

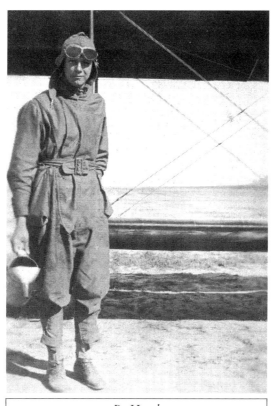

R. Heath

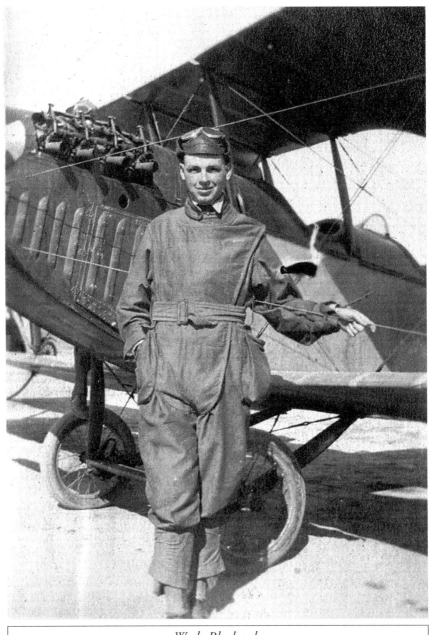

Wade Blackard.

Mr. Pond is a very conservative instructor. He has a method of teaching which is different from the others, and I am becoming convinced that he is right, although at first, I envied some of the other boys their more daring

teachers. The common way of instructing is to give four or five lessons in air work, right and left turns, and straight flying; then start immediately upon landings, and having accomplished this, turn you loose. In this course, you seem to be making very rapid progress. Mr. Pond, on the other hand, gives you twenty-five or thirty lessons in air work. He claims that landings then come naturally to you. You are judged in your progress, however, by the other students, according to the number of lessons you have had in landings, and when you say you have had none, they think you are not getting ahead. I felt this way until I had a long talk with Mr. Pond, and have reasoned out the matter. Up to now, I have had twenty-two lessons in the air on right and left turns, and in gliding. He says that my work has been good, and that he would start me on landings this morning. If I catch on all right, I have great hopes of doing solo work by the end of next week if we have good weather. I am looking forward to it with delight.

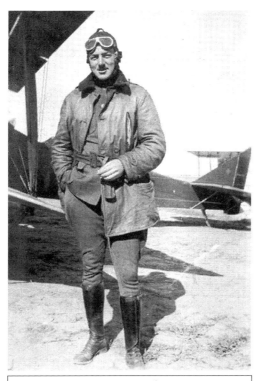

Lt. Green, my first Lt.

Bob Townes drove me out of town for Sunday in his auto. Regular beds, hotel meals, and above all, a hot bath, made the trip worth while. In the evening, we went to the Country Club, and had a regular swim; just think of it!

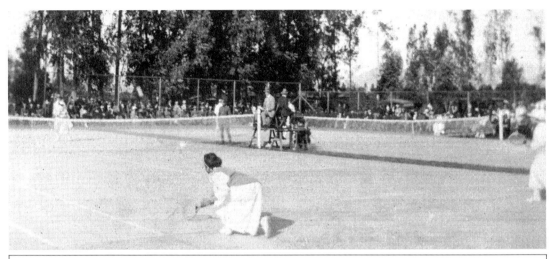

Victoria Country Club, Riverside, Calif. Mrs. Sutton Bundy of Los. Angeles.

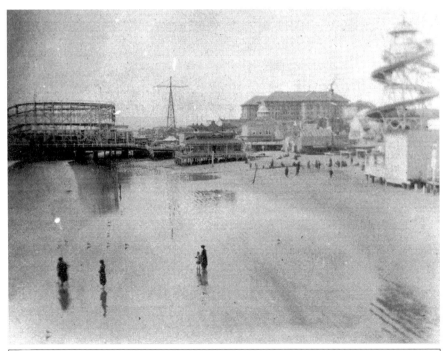

Long Beach, Calif.

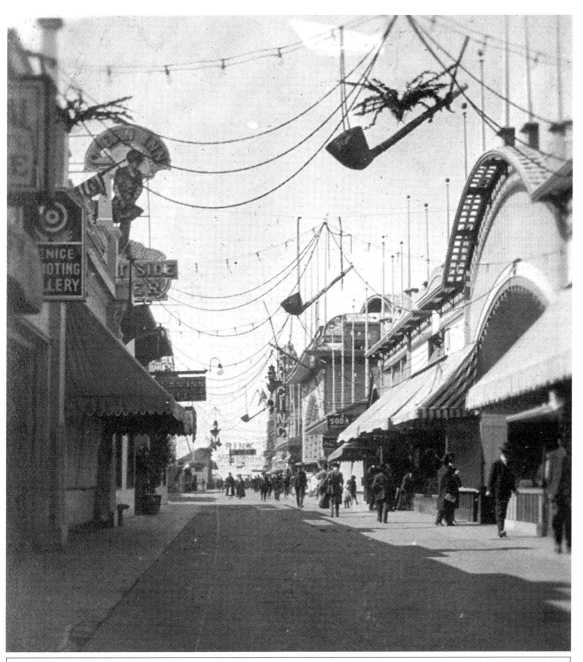

Venice, California on St. Patrick's Day, 1919

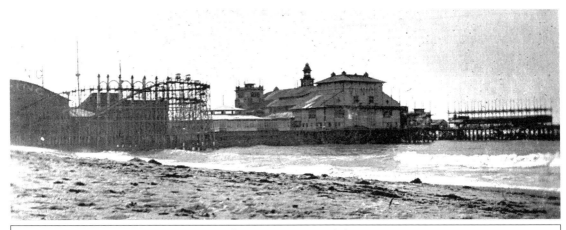

The pier, Venice, Calif.

Mack Sennett's movie stars at Monte Del Rey. Real-reel art. Why men leave home.

The first seven students turned out from this school have been placed on the instructing staff. They were given their commissions, and each has a class. Whether a similar fate shall fall to our lot, I do not know. While this flying game is most attractive to me, I have never wanted to be an instructor. The plan seems to be to split the students here into bunches—some are assigned to instruction—some to Fort Wood.

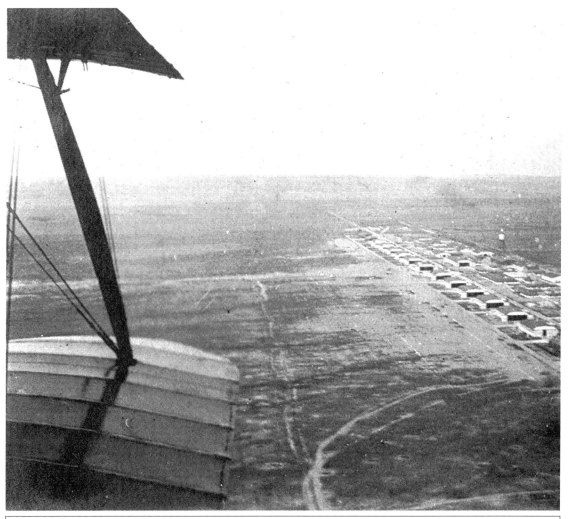

Flying by March Field, Riverside, Calif.

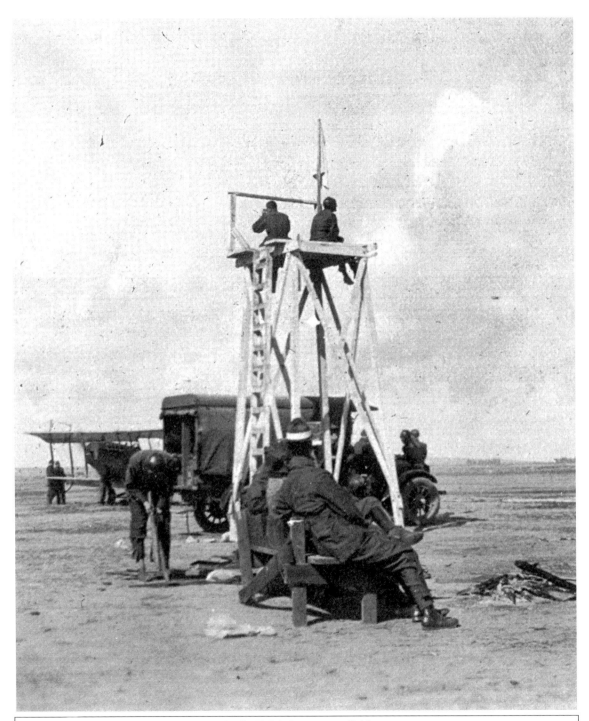

At the R.M.A. gassport field.

The heat for the last few days has simply burned up this flat, dry country. It has been necessary for me to remain in the field under the broiling sun practically all day long in order to keep the record of the flights, and to see that the machines are filled with gasoline and in running order. This gave me headaches at first, and just as I was beginning to become accustomed to it, we adopted a new plan. We asked Mr. Pond if he would not instruct the men on landings early in the morning so we could have the benefit of the cool, still air. After some discussion, he assented, so now, I drive down for breakfast and return to the field for flying at 5:30 in the morning. With this early start, we are able to finish before the hot noon sun, and have more time to work on the machines in the shade before the flights begin at 1:30 for the solo men.

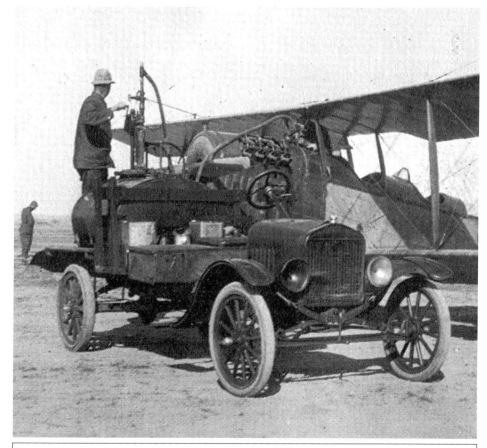

'Gassing up.'

I have come to the conclusion that making a landing is the trick of flying. Last week, I would willingly have taken up a machine alone, with the expectation of having a pleasant trip and an easy finish, but this week, I would not touch one. My first lessons in landing, I am frank to say, scared me considerably. My instructions were to sit back with my hands off the control and watch every move. Next, I was to handle the controls myself. I rose from the ground, circled the field, and endeavored to drop in from the same side from which I left, so as to be continually against the wind. The sensation of having the ground rushing by you, as well as rapidly approaching you, tends to make you somewhat dizzy at first. I brought her down within about fifty feet of the ground, and then gave up. Mr. Pond landed her that time. Then I made another attempt. This time, it was not a good landing, but I felt a little more at ease. It becomes more and more natural, and at last a mere incident of the flying. The trick lies in attempting to judge your altitude and the length of the glide in order to land at a certain spot. I am catching on and if good weather continues, have great hopes of soloing by the end of next week. It remains for me to judge my distances better and perfect the touch on the earth. My landings, as yet, are rather erratic.

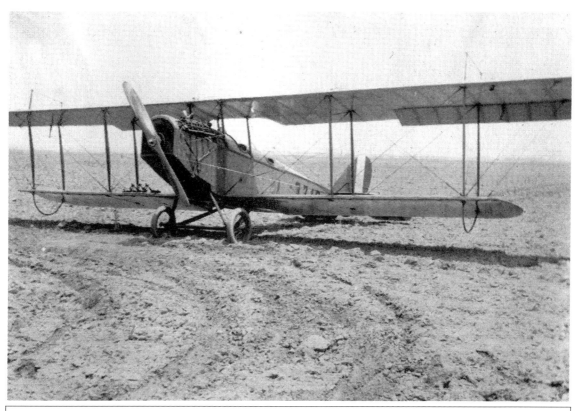

My only accident—a forced landing.

Although we were fortunate here in being exempt, last week seemed to be another period of accidents. At Mineola, a student and an instructor were killed; at Bay Shore, two were killed; and in West Virginia, a student was killed. It is peculiar the way these accidents come in groups. The nearest we came to trouble was that two machines, through carelessness, rose from the ground about the same time, and nearly collided. We have had warning and strict injunction to avoid this, and I think it is not likely to happen again here.

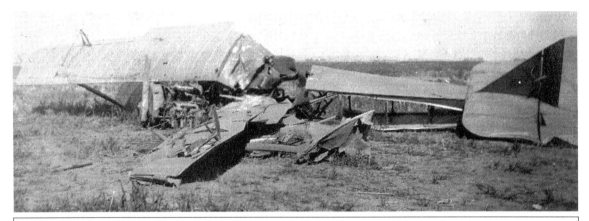

Played too close to the ground. Rippiger was killed in this and Cadet Packard badly broken.

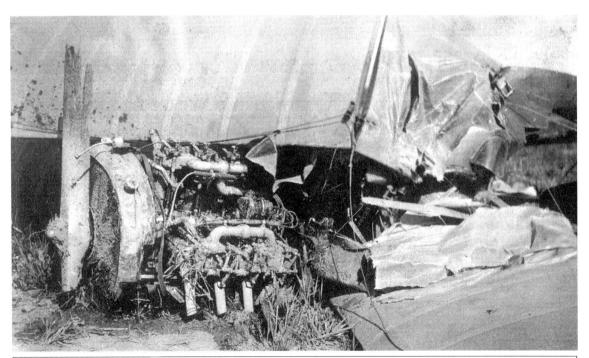

Former Lt. Rippiger's crash. I'll tell about this when I get home.

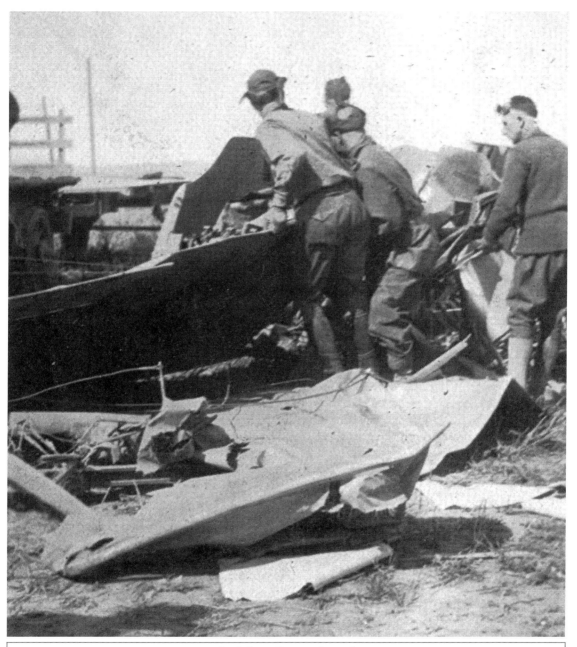

Junk from Rippiger's crash.

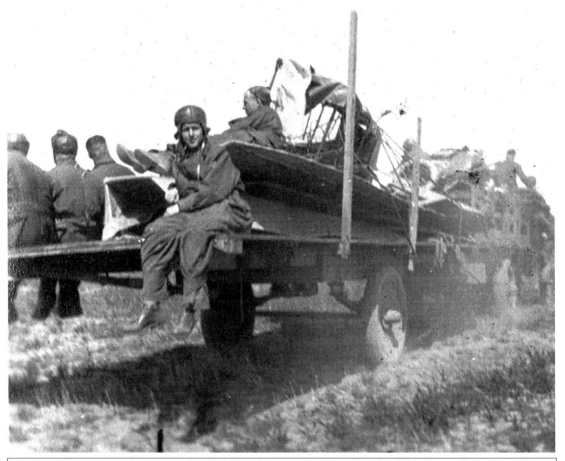

Don Norwood on Rippiger's crash.

At last I am a regular aviator. I realized it with surprise and some nervousness.

Wednesday, I was placed in the back seat and told to continue my instruction in making landings. Every one I made was poor. The slump stayed with me until Friday. I "pan-caked" as they call it, every time. At a height of about two hundred feet, you throttle down your motor. This tips the front part of the machine down, and causes you to glide. Once in a gliding position, it is necessary to hold the front end up, or she will dive too rapidly. You continue your glide earthward until you get within about thirty feet of the ground, when you steepen your glide in order to obtain more

speed. This is the difficult part of landing, because you become nervous, and the natural tendency is to level off too high from the ground. The steep glide should be held until you are very close to the ground—then you level out and hold her in the air as long as possible until she settles to the earth. In the few days, while I was in my slump, on getting near to the ground, I would get nervous and level off about ten feet from the earth, and then, when I lost speed, I would drop to the ground with a bump. Friday, I broke the wing-skid and blew the right tire in a careless landing. I pan-caked, and was lifted back into the air from the heavy bump. The wind got under my left wing, and threw me over on my right side, and broke the tire and skid. It was not very serious, but caused half an hour's delay, and deprived me of that much practice.

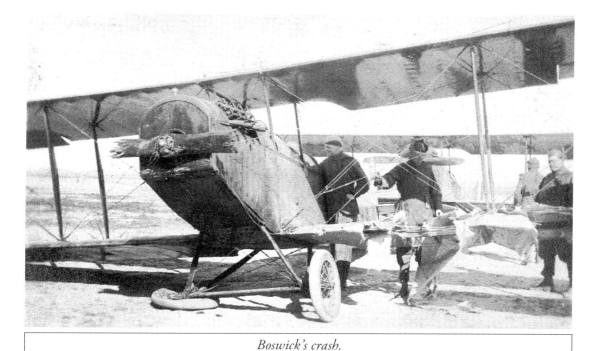

Boswick's crash.

Yesterday, however, I was determined to make good. I headed the list, and got the benefit of the still early morning air. My first landing was poor, and my instructor had to help me with it. The next three, however, were

beauties. I did them all alone, and set the machine on the ground like a basket of eggs. Without another word said, Mr. Pond stepped out of the front seat, lifted the tail around so as to point the nose of the machine to the wind, and said, "Go ahead, Russel, let's see you take her up alone."

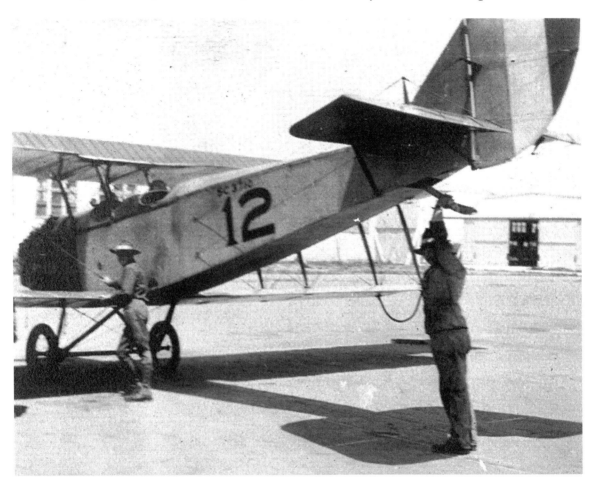

Never before had I missed company so much, but my chance had come at last, so I gave her all the throttle, and started. Taking her off the ground was simple enough, and the air work was even more so, and I felt no worry except for the lack of companionship. At first, it seemed awful to be alone in the wide, wide sky. I thought of the Ancient Mariner, which I used to hate so in the Detroit University School because I had to study it: "So lonesome

'twas that God Himself scarce seemed there to be." When I approached the spot where I had to start my glide for the ground, the nervousness returned. Before, when I was in this situation, I would merely throw up my hands, and Mr. Pond would bring her down; but here I was, about three hundred feet high, and no way to bring her down except to do it myself. My involuntary prayer was, "Why did you let Mr. Pond lie to me, Oh Lord, and tell me I could do it?"

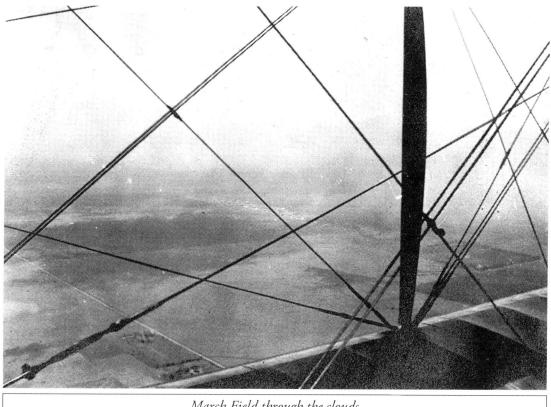

March Field through the clouds.

I reached the point I thought was right, cut off the motor, clinched my hands on the wheel, and started for the ground at about fifty miles an hour. The next thing I remember, I was rolling along the ground, and had made the best landing possible. Mr. Pond came up and said, "Very good. Try it again." This time it was more simple, and there was less nervousness in the

atmosphere, and I finished with equal success; then I tried it two or three times more, and found that I was getting some confidence in myself. A little more experience, and less self-doubt (it seems that I never thought enough of myself), and I will be all right. After the first solo flight, I felt as if I had some right to wear an aviator's uniform.

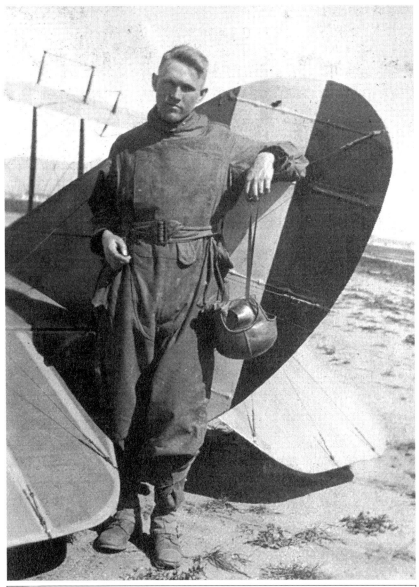

Somebody kick the rudder. (Edward O. Southard)

Friday night was an interesting evening in camp. The instruction in night flying began. The more advanced students, under the pupilage of Lieutenants Laffly, Prevot, and Captain Brown, made the flights. It was a weird and astonishing exhibition, and surely tries the nerves. On one of the hangars five strong searchlights were placed; four gleaming out into the field, and one directly into the zenith. The aeroplane was brought out into the light, started, and was out of sight in a second. Then we could only hear the roar of the motor. Away from the shafts of light you could not see the machine, even close to the ground. We could hear it circle about the field a couple of times, and then it passed through the light like a flash and disappeared. The next minute, the motor had been cut down, and everybody waited breathlessly for the landing. In a second, the machine passed into the light, coming at a tremendous speed. Some three hundred feet beyond it touched the ground with a beautiful tail-high landing, a thing which is usually discouraged. Lieutenant Laffly told me afterwards that he dropped fifteen hundred feet in a short distance into the field, and this accounted for his terrific speed.

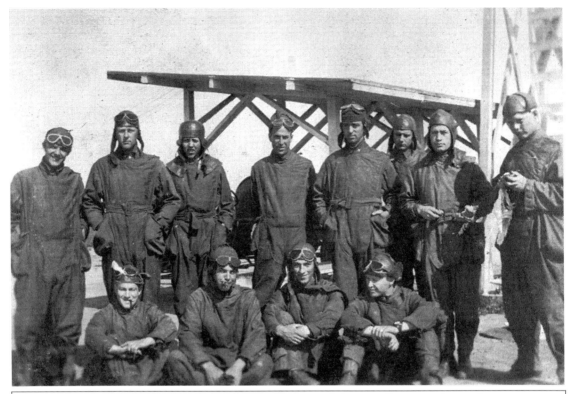

Dizzies: Solo B section—my 1ˢᵗ solo class. (Standing) Slicken, Willson, Lamb, Reed, Scroggins, Morrison, Tauberg, Wendler; (Seated) Speer, Watson, Sampson, Tattersfield.

It is hard to explain it to you, but it was really the most thrilling flight I have ever watched. Probably it was so interesting to me because the task of landing in the day time is still so difficult for me. There were two other flights that evening.

Maury Hill had a nasty accident yesterday. He was cranking one of the machines, which, as you know, are started by the propeller, and it backfired, and nearly broke his wrist. It gave him a bad three-inch cut on the wrist. This morning it is very stiff, but he can move his fingers, so for a wonder, it does not seem to be broken. To be sure, he is going to have an X-ray taken this afternoon.

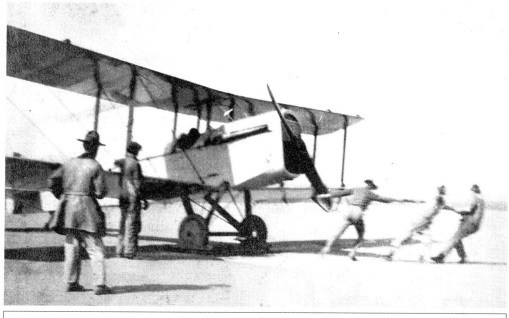

Turning over the Blue-Bird.

Today, Sunday, the day of rest, we have the pleasant task of setting up ten new machines which came last night from the Curtis factory. Orders are that we shall continue work until all are set up ready for flight tomorrow morning. It won't be part of the day's work—it will be all of it.

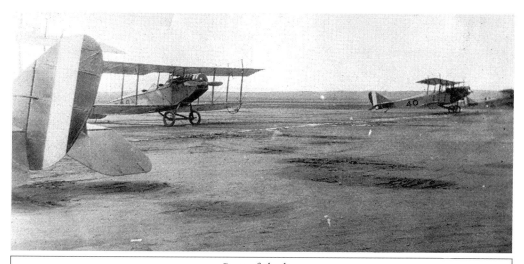

Part of the line.

After I began soloing, I thought I would get a couple of weeks' furlough, but now I am disappointed in this. Lieutenant Hines, in charge of solo flying, was wrought up last Sunday because there were only two men to help him bring the machines out in the field, so he refused to sign any more passes, and Lieutenant Fleckenger will not sign any which exempt men from class work.

Work now is about the same as before, with a little change in the hours. At present I report at 4:30 A. M., and work through until twelve o'clock. The next day I begin at twelve o'clock noon, and work through until the machine is ready for the next day's flying. I have to keep a record of each man's flight, and to see that the machines are in good running condition while I am on duty. Of course, I have time out for my flight, one-half hour each day, and for my classes. The end of the week will, no doubt, bring the last stage of my training (elementary), and then I will take the tests to qualify as a Reserve Military Aviator. There are six tests to be met:

(1) To climb to an altitude of four thousand feet and remain there half an hour.

(2) To make a cross-country flight of sixty miles without a stop.

(3) Cross-country flight to the town of Leroy (forty miles) with a stop there.

(4) To jump an obstacle fifteen feet high, and come to a stop within fifteen hundred feet of the obstacle.

(5) To climb out of a field two thousand feet square to an altitude of five hundred feet. (This is really the most difficult and dangerous.)

(6) To cut off your motor at an altitude of a thousand feet, and glide to the earth, landing within two hundred feet of a fixed mark.

The last requires much skill and practice. Having passed these tests, my first training will be over, and I am recommended for a commission. On completion of these tests, the future work is problematical. It may be

instructing, or being instructed in the use of the machine gun, bombing and other military aeronautic tactics.

German plane on the machine gun range.

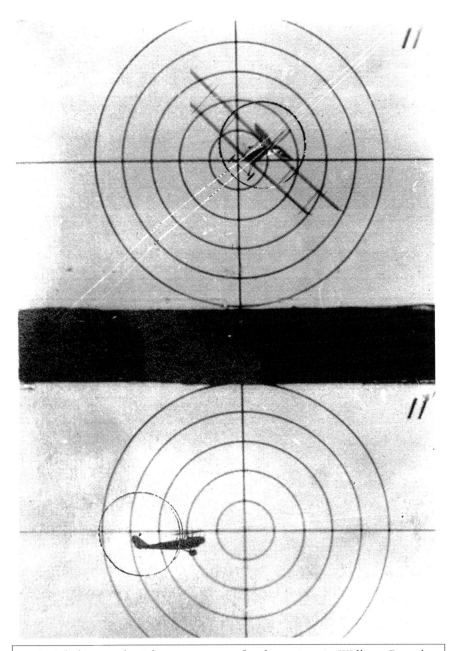

Aerial photograph with a camera gun, foreshortening. As William Russel explained in a letter home, this is a target record of the gun camera, with snapshots taken by pulling the trigger, the same as if the gun was in actual use. The enemy plane is shown within the targets.

I was fortunate the other day in being able to pick up a fine pair of triplex goggles in Chicago. Also, you will be interested in knowing I have a wrist watch. The day I began soloing, I found that my prejudice against it was sentimental, and on the next day I hastened to get one. In the air you want to know the time, and you cannot fumble around in your pockets to find a watch. You are only allowed half an hour for your flying, and the order is strict not to over-run your time. In feeling around for my watch, I nearly had an unexpected loop. So now, the wrist watch for me, and no remarks.

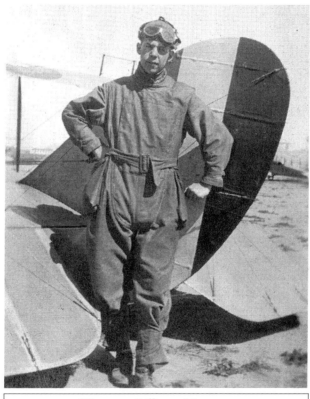

Watson—Billings, Montana.

I have had my first touch of discouragement this past week. An announcement was made that we must have fifteen hours of solo work instead of four, which has been considered ample for any normal person. This means possibly another six weeks' training before tests, and is delaying our entire course.

My own flying has advanced satisfactorily, and I am beginning at last to believe more in myself. On Friday and Monday, conditions for flying were very bad, and after a few flights, flying was called off. I went up both days, and cruised about with a forty mile wind blowing. By exercising watchful care, the rise, the flight in the air, and the landing were all satisfactory. I was rather surprised that there was not more bother, and this experience, more than anything else so far, has given me confidence. They were not the usual pleasant flights, as there was a fight every minute to keep stable, first a bump on one side, then on the other, then a drop, and in a fraction of a second you would go shooting directly up. All the time you had to watch yourself; going with the wind, the speed would be about one hundred miles an hour, and against it, not much more than twenty. It seems to me that I learned more in those two half-hour storm flights than in all the rest of my time. A minute's practice in the exercise of quick judgment and the correction of errors caused by nasty weather counts more than hours of smooth sailing.

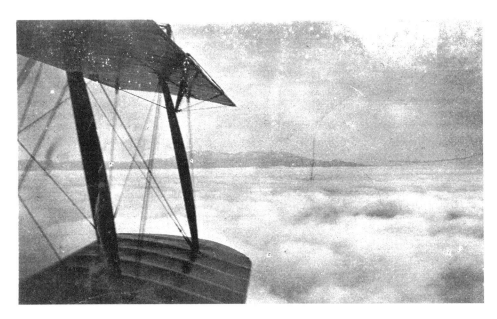

We are busier than ever, and I regret to say that it is necessary to repeat my vaccination and inoculations again. It seems that the doctor failed to make

record in his register in my case and several others. It is a bit of a calamity, and I think that Dr. Brown was, too. We like our new physician very much.

I am enclosing a small photo snapped of me with my fighting face on, just before my first solo. You will observe a few signs of nervousness. Otherwise it is a very good picture, as I now appear.

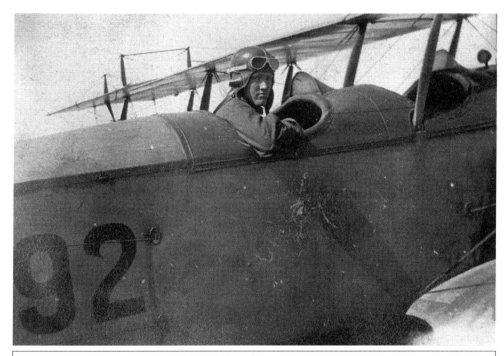

Dressed to kill. (Edward O. Southard)

Those of us who have passed, have little to do but wait. The others have preference in the use of the machines, and only when one is idle do we get a ride. I have managed, however, by being ready at any minute, to squeeze in a fifteen or twenty minute flight each day.

The weather now has become very cold, and we are having our first taste of winter flying. I do not dread it, because I am sure the excitement of flying will keep your mind off the weather, and keep you warm all right.

Today, the last of my Reserve Military Aviator (R.M.A.) tests was successfully completed. The final tests are extended during three days. First, we

were required to climb to an altitude of four thousand feet and remain there forty-five minutes. On the descent, we had to make one spiral to the right and one to the left with the motor shut down. The drop into the field was made with a dead engine from a height of one thousand feet, and the landing within two hundred feet of a designated mark. This is not the most dangerous, but by far the hardest to do accurately. The next was a triangular cross-country flight, covering a distance of sixty miles without a stop. Then, there were three tests, consisting of climbing to an altitude of five hundred feet without going out of the boundaries of a tract two thousand feet square. This is the most dangerous, because one is apt to get into a tail spin on the turns, which is very perilous if you are near the ground. Next, on landing, we had to jump a hurdle fifteen feet high, and land on the other side, coming to a stop within fifteen hundred feet of the hurdle; and last of all, a hundred mile cross-country flight without a stop. I am considered a finished aviator as far as the instruction at this camp goes, and am now only waiting for a commission and the assignment to active duty.

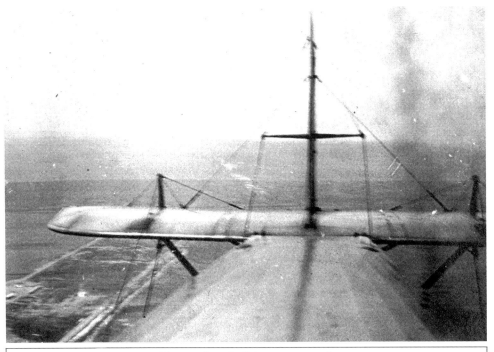

The north end of ship going south.

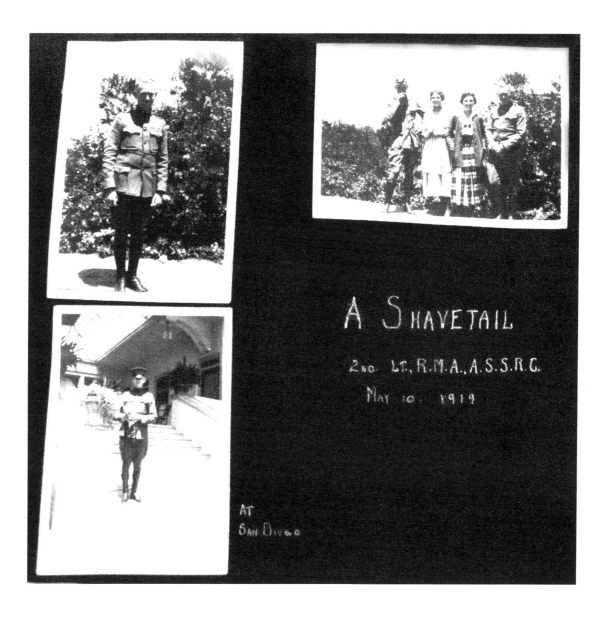

A SHAVETAIL

2ND. LT. R.M.A., A.S.S.R.C.

MAY 10: 1919

AT
SAN DIEGO

EPILOGUE

With the stories told by William Russel's letters home and Edward Southard's photos, we have a rare opportunity to understand just how difficult and tenuous it was to learn to fly in a Jenny. Not only that, it is amazing to think that Edward was able to photograph his flying school experience in 1919—especially with the crude features and large size of a Kodak No. 2 Brownie camera! It's not like it autofocused, or would have been easy to hold onto in an open-air cockpit of a Jenny! One can just imagine it getting tossed about the skin floor of the Jenny after Edward put it down to land the plane.

Curtiss JN-4 "Jenny" biplane

One report puts the total number of Curtiss Jennys built at 6,813, but only about 50 survive today in museums and with private owners.

Edward O. Southard

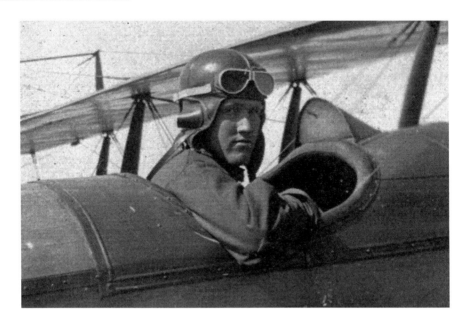

After having learned to fly in a Jenny, Edward hung up his wings and settled back into his life in Elgin, Illinois. He attended the University of Illinois, married in 1922, and had two daughters: Barbara and Carolyn "Connie". Connie became a stewardess for United Airlines, flying in DC-3s in the late 1940s.

The town of Southard, NJ was named after Edward.

Throughout his life, harkening back to his days learning to fly a Jenny and seeing the 'daily crash,' whenever Edward heard an ambulance coming he was fond of saying "There goes the meat wagon!"

William Muir Russel

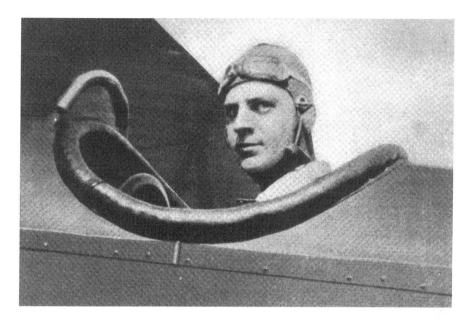

William Russel went to France less than 4 months before the Armistice was signed ending the war. He participated in many air battles as a pursuit pilot at Chateau Thierry. In one battle, on August 11, 1918, four Boche planes were downed. That morning, just one year from the day he wrote, "At last I am a regular aviator," he was the rear guard of a patrol of thirteen Spad, type 13, 220 H. P. planes, and flying very high—higher than the other machines and well behind them. He was cut off by a formation of five German Fokkers which came out of the sun upon him over the vicinity of Vauxcere, France. Although at a great disadvantage, his companions saw him immediately engage and attack the enemy planes. William handled his craft with skill and strategy, but became separated from his companions in the dog fight, and they never saw him again. He had just made a double *renverse,* when he must have been hit and started for his own lines. Very soon the plane suddenly fluttered as if it had no control, glided and crashed to the earth. One of his companions in the air battle wrote: "We got two

of the Boche planes, but it was dreadfully hard luck just the same. Bill had fought his last fight, and he was the kind we hate to lose."

On the same day, William Muir Russel was buried by strangers in the grave where he now lies in the Communal Cemetery of the Village of Courville, France.

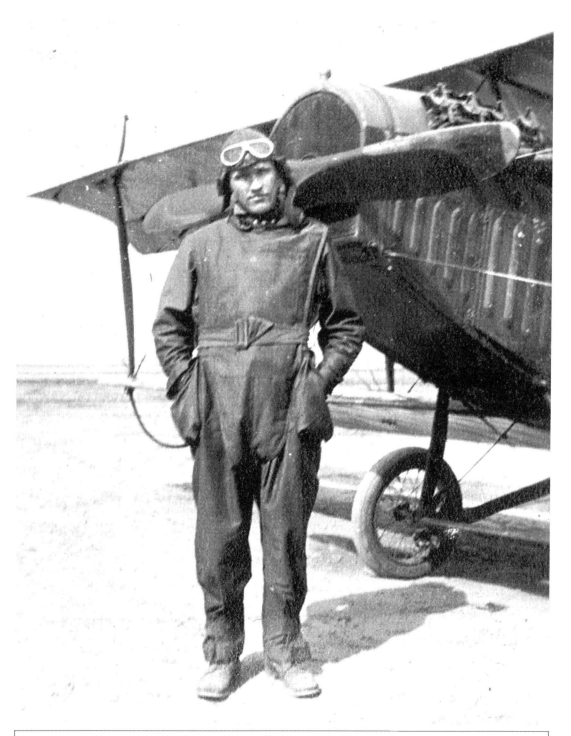

Old 'Dizzy' himself (Edward O. Southard)

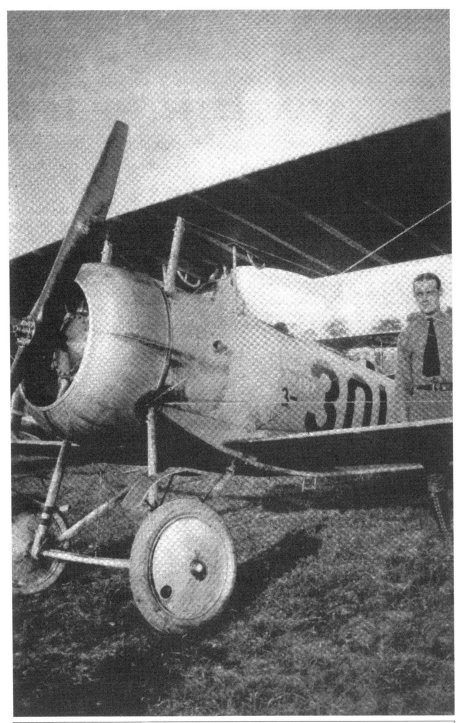

15 Metre Nieuport Pursuit Plane (William Muir Russel)

Made in the USA
Middletown, DE
31 July 2016